P9-DCI-920

IMAGES
of America

LOS ANGELES'S
CHESTER PLACE

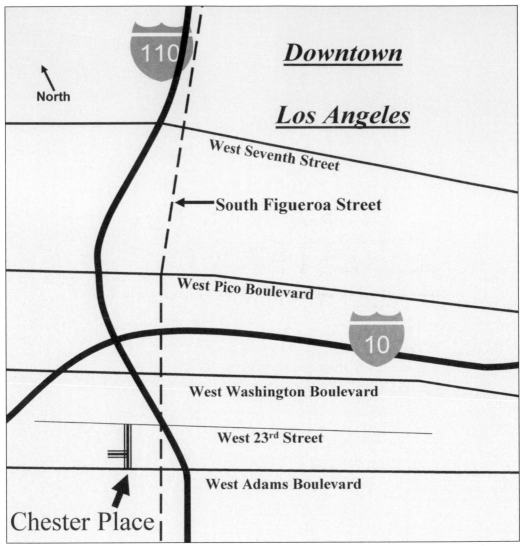

The Harbor Freeway (Interstate 110) starts from downtown Los Angeles to San Pedro at the Port of Los Angeles on the west side of Figueroa Street. But before reaching Chester Place, the freeway suddenly curves, dives under Figueroa Street, and continues for a mere seven blocks completely below ground level before proceeding for several miles along the east side of Figueroa Street. The Los Angeles City Council approved the route by a vote of 11-2 on August 11, 1950, despite city councilman Kenneth Hahn's objection that proper hearings had not been held. The curve spared Chester Place, and the short stretch below ground level saved the residents from traffic noise. While some shift was desirable because of the presence of the University of Southern California campus and Exposition Park in the neighborhood, the positioning was exceptionally favorable to the influential residents of Chester Place.

ON THE COVER: The Twenty-third Street gates protect Chester Place on the north but are less pretentious than the West Adams Boulevard gates. With her husband often away on business, Estelle Doheny hired a watchman. By the time of her death, there were six guards who worked in shifts to watch over the gated community. (Security Pacific Collection/Los Angeles Public Library.)

IMAGES
of America

LOS ANGELES'S
CHESTER PLACE

Don Sloper

ARCADIA
PUBLISHING

Copyright © 2006 by Don Sloper
ISBN 0-7385-4687-9

Published by Arcadia Publishing
Charleston SC, Chicago IL, Portsmouth NH, San Francisco CA

Printed in the United States of America

Library of Congress Catalog Card Number: 2006931272

For all general information contact Arcadia Publishing at:
Telephone 843-853-2070
Fax 843-853-0044
E-mail sales@arcadiapublishing.com
For customer service and orders:
Toll-Free 1-888-313-2665

Visit us on the Internet at www.arcadiapublishing.com

CONTENTS

ACKNOWLEDGMENTS

This book would not have been possible without the collaborative effort of more than 20 individuals and institutions that graciously provided memorabilia and pictures from their collections. Jim Robinson, a neighbor in St. James Park, provided editing, guidance, and material from his extensive collection. Sr. Jill Napier, CSJ, generously made available archives from the Sisters of St. Joseph of Carondelet, Los Angeles Province, which provided invaluable data about the history of the neighborhood. Sr. Mary Irene Flanagan, CSJ, supplied material gathered for her 1967 thesis from the Title Insurance and Trust Company and Security Pacific Bank, companies that no longer exist. Sister Flanagan also supplied rare insight from her years living on Chester Place and her interviews with Chester Place residents and employees of the Doheny family. Dr. Jacqueline Powers Doud, president of Mount St. Mary's College, extended the resources of the college in preparation for the book, and the staff of Dr. Stephanie Cubba, vice president for institutional advancement, was particularly helpful. And no discussion of the Doheny family would be complete without insight and counsel from Rev. Msgr. Francis J. Weber and the files of the Archival Center, Archdiocese of Los Angeles (AALA). Dr. James Smythe opened the collection at Pepperdine University and provided helpful insight on the Seaver family. Annie Laskey from the Los Angeles Conservancy offered her mother's postcard collection, and Connie Rothstein made available her collection of early Los Angeles material. The docents for tours of the Doheny Campus of Mount St. Mary's College shared their enthusiasm and contributions, particularly Liz Staley, Mary Baum, and Deborah Morris Greene. The descendents of families who lived on Chester Place or were touched by their affairs were generous in their cooperation, including the Vail family, Gene KleinSmid of the Von KleinSmid family, Roy Fazzi, and Joe Nicassio. Important contributions were made by Frank Damon and Vincentian archivist Fr. Stafford Poole. C. M. Photographs not otherwise credited are from the author's personal collection. But most important of all has been the help of my wife, Mary, who encouraged and assisted me throughout the project and kept me organized and focused.

INTRODUCTION

Incredibly intact after more than a century, the houses of Chester Place now form the home of the Doheny Campus of Mount St. Mary's College. They offer a glimpse of the lifestyles of the wealthy residents who lived in them at the beginning of the population explosion that created today's city of Los Angeles. In 1900, as the first houses were completed in the gated community, the U.S. census reported the city's population at 102,479—double the population of only 10 years earlier. The dramatic growth was tangible proof of the economic factors that had created a new wealthy class: the arrival of the transcontinental railroads; the city's reputation for a healthy climate, which had attracted rich families from across the United States and Europe; the local discovery of oil; and rampant land speculation. The growth continued as the census exceeded one million by 1930, two million by 1960, and three million by 1990—a population of newcomers generally unaware of the city's history or the iconic neighborhood of the past, located immediately south of downtown.

But the preservation of the Chester Place mansions is also the story of the Doheny family, who moved onto the street in 1901 and quickly came to dominate the neighborhood. Estelle Doheny acquired and maintained the entire area until her death in 1958, and her will resulted in the property that became today's Doheny Campus of Mount St. Mary's College.

In 1853, Henry Hancock, a New Hampshire lawyer, was hired to survey southwestern Los Angeles, a city requirement for land sales. In Hancock's survey, the dirt roads running east-west were given the grand designation of "boulevards" and named in honor of Pico, the city's most prominent political family of Mexican heritage, and U.S. presidents Washington, Adams, and Jefferson. Between the boulevards were generous, 35-acre lots. Hancock purchased one of the choicest lots, the future location of Chester Place, in 1855.

Hancock acquired several major acreages in the Los Angeles area, buying the future site of the city of Beverly Hills in 1854 and selling it two years later. In return for legal fees and cash, he acquired Rancho Las Cienegas, what would become the La Brea oil field, the "Miracle Mile" section of Wilshire Boulevard, and the residential section of Hancock Park. But before there was an exclusive residential neighborhood in Hancock Park or a Beverly Hills, there was Chester Place.

Hancock sold the property that became Chester Place in 1876. At the time, the neighborhood was occupied by a few early landowners with fruit groves and Chinese farmers who leased land to grow crops for the city's markets. By the time Chester Place was subdivided in 1899, the neighborhood had become the city's most desirable, thanks to its public transportation, fertile land, abundant water, and proximity to Agricultural Park. These benefits resulted from a series of seemingly random factors, many of which date back to the city's founding: the largess of a king, suppression of vice in a lawless city, the changing course of a river, and the creation of a university by developers anxious to profit from their surrounding land.

In 1781, King Carlos III of Spain granted foursquare leagues of land, a tract of almost 28 square miles, to create the new pueblo of Los Angeles. The area that would become Chester Place was

located near the southwest corner of the city's boundaries. The location near the city limits would prove important to the area's early development.

After the American takeover of California from Mexico in 1846, Los Angeles became a lawless community with a "wild west" reputation, as gambling, opium dens, prostitution, and public drunkenness led to violent deaths from gunshots, knifings, and both public and lynch-mob hangings. In the 1870s, new railroad lines brought an influx of more law-abiding citizens. Spurred by the new residents and the organized religious community, the city passed and, more importantly, enforced laws against what was seen as indecent and disruptive behavior.

As often happens when a city becomes restrictive, the disapproved activities moved just outside the royally granted city limits. Agricultural Park, now known as Exposition Park, located on the city's southern border, offered racing, gambling, women of easy virtue, and what was described by a contemporary as the "biggest bar I've ever seen." In 1874, the city council authorized a new streetcar line running from the historic core near the old plaza to Agricultural Park on the city's southern boundary. The route ran south on Main Street past the then new St. Vibiana's Cathedral before cutting west on Washington Boulevard to Figueroa Street, then south to Agricultural Park. Thus, the area of orange groves and farming along Figueroa Street acquired convenient transportation to the city's growing downtown.

When the Spanish settled Los Angeles in 1781, the Los Angeles River flowed south along the east side of what is now downtown Los Angeles, then curved through the southwest corner of the pueblo and continued west, exiting to the ocean in Santa Monica Bay. In 1815 and 1818, a series of severe floods blocked the channel with debris, forcing the river to flow south to San Pedro Bay. That change in course had a dramatic influence on the area's future development. The old channel, including the area that would become Chester Place, was prime agricultural land, with a high-water table and virgin soil deposited by the river during previous floods. The former channel also offered an easy downhill slope for a "zanja"—the Spanish word for canal—that brought water from the Los Angeles River down Figueroa Street beyond Adams Boulevard. It was the availability of water that determined the value of property. And the land in the old river channel was valuable indeed.

The combination of available transportation and water encouraged three real estate investors—lawyer Robert Widney, horticulturist Ozro Childs, and former governor John Downey—to buy a tract of land immediately north of Agricultural Park for development. To make their home sites more attractive, they donated 308 lots southwest of Figueroa Street and Jefferson Boulevard, plus some nearby lots, for a university sponsored by the Methodist Episcopal Church. The new University of Southern California opened in 1880 with Rev. Marion M. Bovard as president. After several difficult years, USC stabilized financially and later led the battle to incorporate Agricultural Park into the city of Los Angeles. Renamed Exposition Park in 1910, it became the site of the Los Angeles Coliseum, home of the 1932 and 1984 Olympics.

One

FERTILE LAND

The canals that brought water from the Los Angeles River retained their Spanish name of "zanja" in the new American city of Los Angeles. The city's first canal, called the "zanja madre," or "mother ditch," brought water to the old plaza and fields and was the first public project after the pueblo was founded in 1781. More zanjas were added, and in 1868, a dam was built upstream, supplying water to Figueroa Street.

An extension ditch brought water westward along the south side of Adams Boulevard, encouraging real estate sales in the sparsely populated, heavily agricultural area. Among the buyers was Nathan Vail, a sea captain from New Jersey, who on July 26, 1876, bought 17 acres of Henry Hancock's land on the north side of Adams Boulevard, just west of Figueroa Street. Vail built a two-story farmhouse behind a monumental, stone-and-iron gate on Adams during a real estate boom that saw the creation of dozens of subdivisions before a crash in the late 1880s.

Vail participated in some of these land developments, teaming up with other investors, including Judge Charles Silent, an attorney and real estate investor who had recently moved from the Arizona Territory, where he had been a federal judge. On November 5, 1885, Silent purchased Vail's property on Adams Boulevard for his family home. In 1887, Vail and Silent invested in the Centinela-Inglewood Land Company, established by Daniel Freeman, the owner of Rancho Centinela, to develop the town of Inglewood. That same year, they formed another company, the Redondo Beach Development Company, buying 433 acres from the Dominguez family. It was an unlucky investment. In 1888, Vail drowned while attempting to reach an offshore ship, and the following year, Judge Silent sold the company to two entrepreneurs from Oregon, who completed development of the harbor.

In 1899, Judge Silent moved his home, the former Vail house, to the rear of his grounds. He extended Vail's old driveway north to Twenty-third Street, renamed it Chester Place, and subdivided the property into 23 lots on each side of the private street.

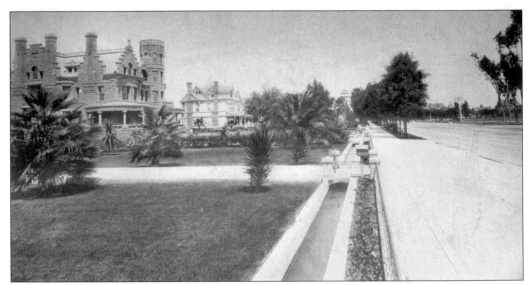

Looking north up the west side of Figueroa Street from West Adams Boulevard, water flows gently toward the photographer through Zanja 8-H, an open concrete ditch. At left are the mansions of lumberman Thomas D. Stimson, 2421 South Figueroa, and banker Jonathan Slauson, 2345 South Figueroa. Slauson acquired Azusa Rancho in 1880 and subdivided the city of Azusa seven years later. (Sisters of St. Joseph of Carondelet.)

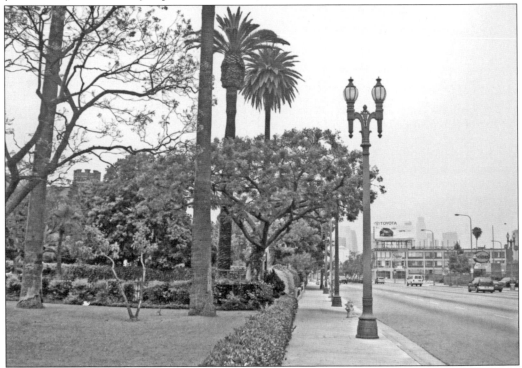

Looking northward on Figueroa Street from the same location today, towering palm trees dwarf the streetlights. A hedge marks the path of what had been the open zanja. The foliage has grown, making the four-story tower of the Stimson House barely visible to the left. In the distance to the right is the skyline of downtown Los Angeles.

Looking south along the 2300 block of South Figueroa, the zanja flows past the estate of physician Walter J. Barlow toward Slauson's home. The concrete-lined canals were two feet wide and one yard deep. The site is now the location of St. Vincent's Parochial School. (Marlene Laskey Collection.)

The only known remaining evidence in a residential neighborhood of the city's once ubiquitous concrete-lined zanjas lies between a hedge and low fence in front of the former Frank Sabichi home at 2427 South Figueroa. Born in 1843 in California, Sabichi was a real estate investor and Los Angeles city councilman. Today the property is the parking lot for St. Vincent's Church.

Tourists delighted at the sight and sound of the gurgling zanjas, but demands for a more efficient and sanitary system forced a conversion to underground pipes, beginning in the 1880s. The zanja on the south side of West Adams Boulevard closed in 1901. The last to close was the Figueroa zanja, above, which stopped operating in 1904. (Marlene Laskey Collection.)

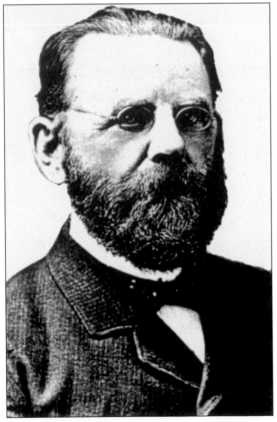

Sea captain Nathan Vail was born in 1825 in New Jersey and made a fortune carrying cargo between Newfoundland and England. He commanded his own ship when he sailed from England to Los Angeles in 1876 to seek new opportunities. Vail, his wife, and six children initially stayed at the Pico House by the old plaza while he purchased land and arranged to build his house.

Anna Walker Vail, Nathan's wife, was born in 1830 in Nova Scotia, Canada, and accompanied her husband during his career at sea. Her first four children were born in Canada, the next in New Jersey, and the last in London, England. She survived her husband's accidental death by 25 years and died in Pasadena in 1913. (Empire Ranch Foundation/Laura Vail Ingram.)

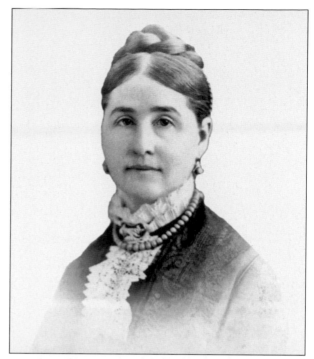

About 1885, West Adams Boulevard near Nathan Vail's property boasted curbs and sidewalks, a clear sign of the improvements of Los Angeles south of the old Spanish plaza. The mature shade trees were a tribute to the area's ready supply of water, which also supported nearby orange groves. In the 1880 census, Vail's closest neighbors included a capitalist, a farmer, and Chinese tenants who rented land to grow vegetables. (Sr. Mary Irene Flanagan, CSJ.)

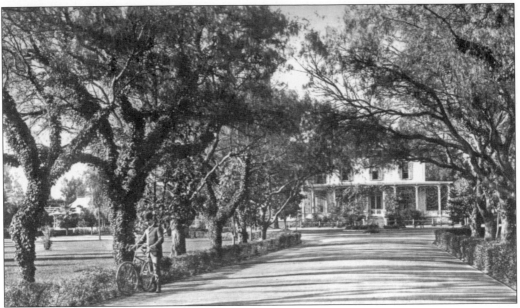

Vail called his new home "Los Pimentos," named for his pepper trees. The two-story, Victorian-style, wood-frame house featured an attic with dormer windows. Vail was 51 years old when he arrived in Los Angeles, and he immediately established a second career investing in real estate. During the next 10 years, land prices sharply increased as the population grew. (Sr. Mary Irene Flanagan, CSJ.)

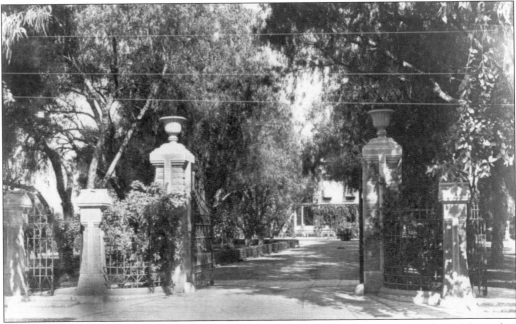

Vail's home is seen here behind the imposing gates he added on Adams Boulevard. On November 5, 1885, he sold the property to Judge Charles Silent, an attorney and investor. Two years later, the discovery of a marine canyon that allowed vessels close to shore led Vail and Silent to form the Redondo Beach Development Company and to buy land to build a pier. (Seaver Center for Western History Research, Los Angeles County Museum of Natural History.)

Cattle graze on the Empire Ranch in the early 1880s, after Nathan Vail and his wife loaned his nephew Walter Vail money to buy the property, 52 miles southeast of Tucson, Arizona. A silver discovery in 1879 helped assure the ranch's financial success and expansion. As the operation prospered, Walter Vail moved to Los Angeles in 1896 to invest in the city's growing real estate market. In 1901, the family bought the 52,794-acre Santa Rosa Island, off the coast of Santa Barbara, for ranching operations. The family sold it in 1986 to the National Park Service but retain hunting rights until 2011. In 1903, Walter Vail led the incorporation of Huntington Beach and built a pier. Vail was killed in a streetcar accident in Los Angeles in 1906. The ranch houses of the Arizona ranch, which at its peak covered 1,800 square miles, were acquired by the U.S. Bureau of Land Management in 1988 and are now part of the Las Cienegas National Conservation Area. A nonprofit Empire Ranch Foundation is dedicated to preserving the ranch's buildings and history. (Empire Ranch Foundation/Laura Vail Ingram.)

Tragically Nathan Vail drowned on May 5, 1888, as he tried to reach a ship offshore in a storm. The next year, as Los Angeles's economy faltered, Judge Silent sold the Redondo Beach Development Company to J. C. Ainsworth and Capt. R. R. Thomas. Redondo Beach flourished as a port for Los Angeles before the federal government built a breakwater at San Pedro. (Robinson Collection.)

Born in Germany, Judge Charles Silent moved to California at the age of 13, trained as an attorney, and in the 1870s, was named a federal judge in the Arizona Territory. Returning to California for his health, Silent became one of the city's leading attorneys and real estate investors. Always interested in horticulture, Silent was one of the leaders in establishing the local park system. (Sr. Mary Irene Flanagan, CSJ.)

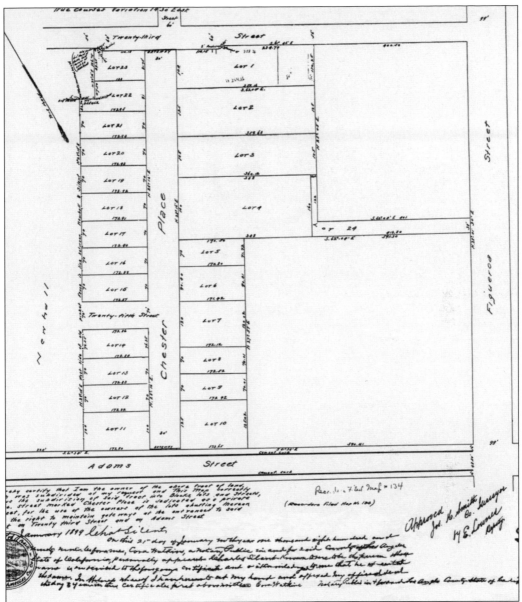

On January 21, 1899, Judge Silent received approval for subdividing his property into "blocks, lots and streets. The street marked Chester Place is dedicated as a private street, for the use of the owners of the lots abutting thereon with the right to maintain gateways at the entrances to said street on 23rd Street and on Adams Street." Silent named the street and subdivision after his son, Chester, who graduated from Stanford University with a bachelor's degree in 1907. Chester returned to Stanford in the fall to study law, but was reported missing by his classmates. On October 2, he was found dead from a gunshot wound in a nearby marsh, an apparent suicide. (Los Angeles County Recorder.)

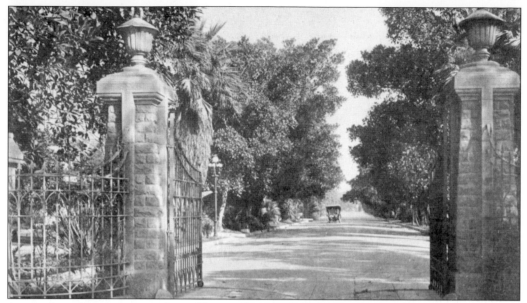

A vehicle makes its way south on Chester Place toward the West Adams Boulevard gates after 1903, when the city's first residential streetlights were installed. Vail's former home has been moved to the north end of the property and is no longer visible from West Adams Boulevard. (Marlene Laskey Collection.)

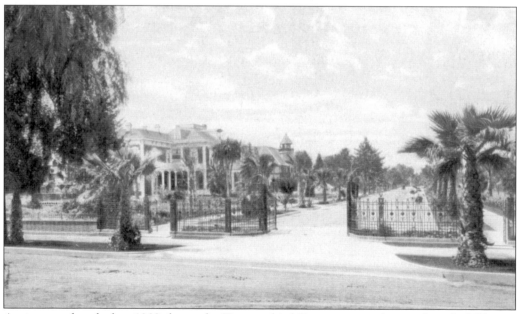

A picture taken before 1902 shows the Twenty-third Street gate at the north end of Chester Place. On the left is Nathan Vail's former home, moved by Judge Silent to 4 Chester Place from 711 West Adams Boulevard. Above the foliage in the center is the four-story tower of 8 Chester Place. (Robinson Collection.)

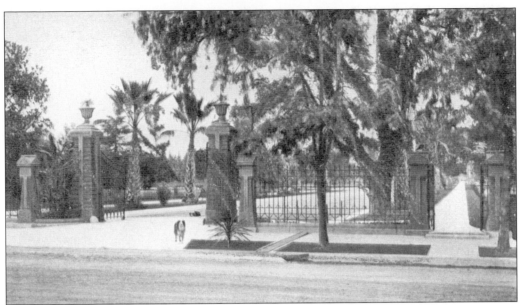

Before 1901, a dog stands in front of Nathan Vail's old flower-pot-topped main gates at the West Adams Boulevard entrance to newly created Chester Place. Barely visible between the gates, another dog lies on the ground undisturbed by traffic. Although automobiles existed at the time, horses powered most travel. (Marlene Laskey Collection.)

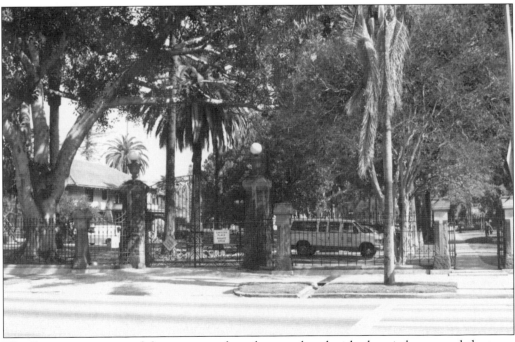

The flower pots on top of the gate posts have been replaced with electric lamps, and the trees have grown or been replaced, but otherwise, the entrance to Chester Place remains the same today, including the storm drains that lead under the sidewalk to West Adams Boulevard. The increased traffic of the past 100 years has led to parking on Chester Place and a crosswalk for pedestrians. (Frank Damon.)

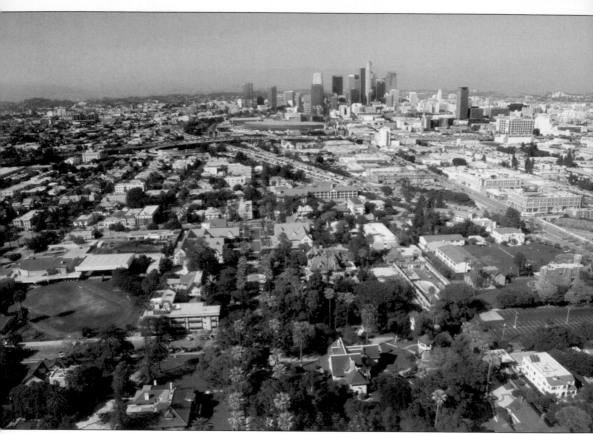

Looking north from above West Adams Boulevard, Chester Place, now the Doheny Campus of Mount St. Mary's College, is lined by two rows of palm trees stretching to Twenty-third Street, with the towers of downtown Los Angeles in the distance. The abundant vegetation obscures many of the mansions. Left of the palm trees at the bottom, the multichimneyed building is No. 17, on the west side of Chester Place. Across the street, to the right of the palms is 10 Chester Place, with its cupola-topped two-story gazebo behind it. Between downtown and Chester Place, the curve of the Harbor Freeway (Interstate 110) can be seen as it shifts to the east side of Figueroa Street and drops below ground, bypassing the exclusive neighborhood. (Mount St. Mary's College.)

Two

OPULENT MANSION

On December 15, 1899, the *Los Angeles Times* gushed about "the handsome residence of Mrs. S. E. Posey, now approaching completion on Chester Place, formerly the private grounds of Judge Silent on Adams Street. It is situated in one of the best residential districts of the city."

Sara Posey, a leading socialite, painter, and real estate entrepreneur, had bought more than two acres on the east side of the street, immediately south of the relocated 4 Chester Place, from Charles Silent when he filed his subdivision plan. She then hired noted Los Angeles architects Sumner P. Hunt and Theodore Eisen, a neighbor on Figueroa Street, to design a stately, three-story house and basement. Its exterior was an eclectic mix of French and Gothic Renaissance styles, with an octagonal, four-story tower. Inside were 22 rooms, many in hunting-lodge style with game trophies.

The first two new houses in the subdivision were the Posey home at 8 Chester Place and John Houghton's house at 10 Chester Place. Both were occupied by June 1900. By the end of the year, 1 Chester Place and 17 Chester Place were occupied, and by 1903, eight additional homes had been completed.

Oliver Posey, a mining engineer and investor, had moved to Los Angeles from Colorado with his wife, Sara, and two sons in 1893. They lived on Figueroa Street near West Adams Boulevard before building 8 Chester Place. But with Oliver frequently out of town on business, his wife tired of the huge mansion and sold it on October 24, 1901, to oil millionaire Edward Doheny and his wife, Estelle, for $120,000 cash. The Poseys moved to a nearby home at 421 West Adams Boulevard and later to Pasadena.

Starting with the original house, the Dohenys supervised a number of additions and changes to the home, the surrounding buildings, adjacent properties, and the grounds during the next 58 years. In the process the house was transformed into an opulent 24,536-square-foot mansion.

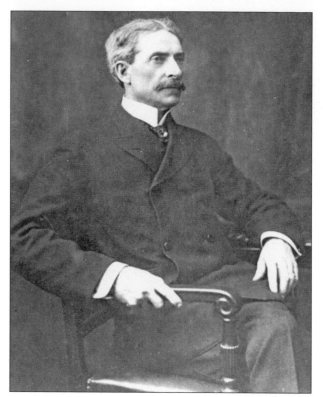

Born in Ohio, Oliver Posey was 15 when he enrolled in the Indiana Infantry at the start of the Civil War. He fought in 17 Civil War battles and was one of 23 survivors from his original company of 60 men. Discharged as a sergeant, he completed a degree in civil engineering and became wealthy as a partner in a Colorado gold mine. He later bought and sold several large mines. (Sr. Mary Irene Flanagan, CSJ.)

"One of the wealthiest women in Los Angeles, she is a leader in charitable and church work," proclaimed the *Los Angeles Times*, describing Sara Posey. A talented woman in many fields, Posey was the driving force behind building 8 Chester Place. She sold the furnished house to Edward and Estelle Doheny, retaining a small number of personal items. The sold furnishings included her paintings. (Sr. Mary Irene Flanagan, CSJ.)

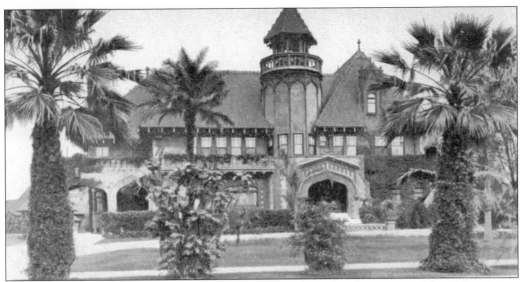

When completed in 1900, the house had 22 rooms. But the third floor was a large, open space, leaving ample room for expansion. The tower at the west-facing front of the house had no windows on its third level, and the third floor's only light from the front of the house came from one dormer window. The second floor had a sleeping porch above the carriage entrance, at left. (Marlene Laskey Collection.)

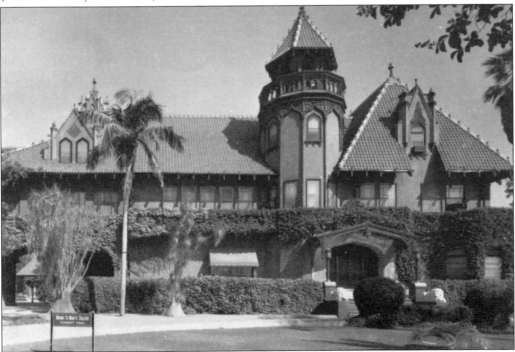

In the 1920s, the Dohenys extended the second and third floors over the carriage entrance and installed an elevator. Windows were added to the tower's third floor, and a dormer window in the third-floor addition gave light to an office Estelle used for managing her expansive book collection. The carriage entrance has a two-level landing so visitors on horseback could mount or dismount. (Sisters of St. Joseph of Carondelet.)

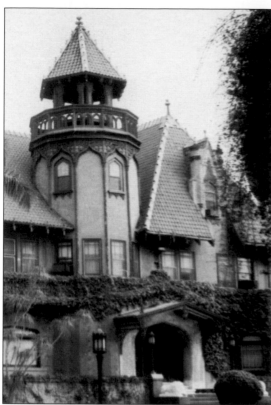

The four-story tower is a focal point of the house. Its top level can only be reached from the rear by crossing the red-tiled roof on a series of ladders and climbing over the tower railing. On one occasion, a musician made the hazardous climb to the top to play an instrument. (Sisters of St. Joseph of Carondelet.)

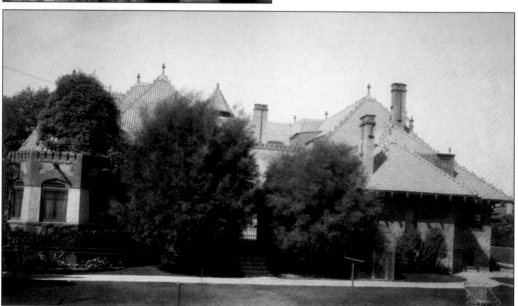

At the back of the house, several rooms looked out onto a beautiful, Spanish-tile patio, allowing natural light into the rooms. A wall around the patio ensured privacy. To the right was the kitchen, and to the left was a freestanding Japanese tearoom. Stairs at the rear of the patio led down to the east lawn. In 1906, the patio was replaced by the Pompeian Room. (Sisters of St. Joseph of Carondelet.)

The new Pompeian Room, whose ivy-covered wall can be seen at right, was attached to the once freestanding tearoom, which became a secretary's office for the Dohenys. The office has a private entrance accessible by an outside stairway, which was constructed to allow employees and job applicants to enter without disturbing the family. (Sr. Mary Irene Flanagan, CSJ.)

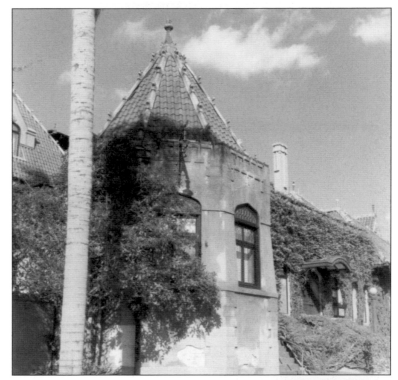

Before the Pompeian Room was built, the Oriental Room, which had shaded windows, looked onto the rear patio. Today the Oriental Room windows—shorn of their awnings—look into the Pompeian Room's marble interior. In this south-facing photograph, the rear entrance to the Great Hall is to the right. The patio was the scene of wonderful parties given by the Poseys and Dohenys. (Sisters of St. Joseph of Carondelet.)

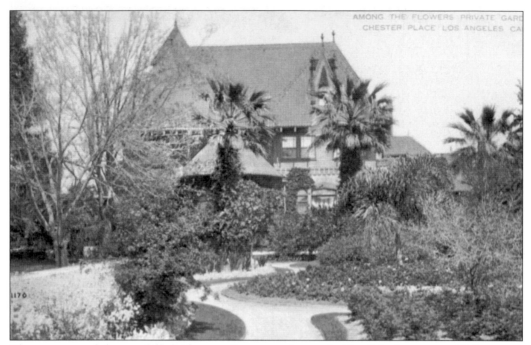

The area around the carefully laid out walkways on the south side of the house provided space to grow lush plants and a variety of trees. Trees and shrubs from across the United States, Europe, Asia, Australia, and the Pacific islands were purchased to create a wonderland of vegetation, with brilliant colors that changed with the season. The floral display was rarely static, as older plants were replaced with new arrivals. (Robinson Collection.)

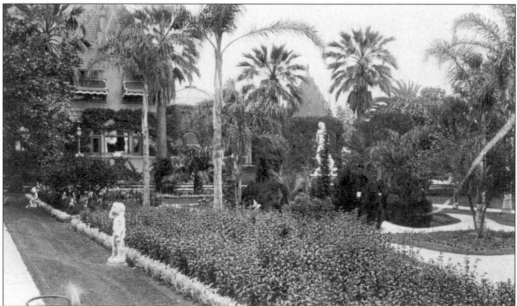

These gardens show the influence of the Victorian era (1837–1901). Gardening became popular during Victorian times as prosperity and leisure time grew and as a more diverse plant stock from exotic lands became available. Ornamental fixtures, including chairs, fountains, urns, planting boxes, and statues, were scattered about the landscape. (Sr. Mary Irene Flanagan, CSJ.)

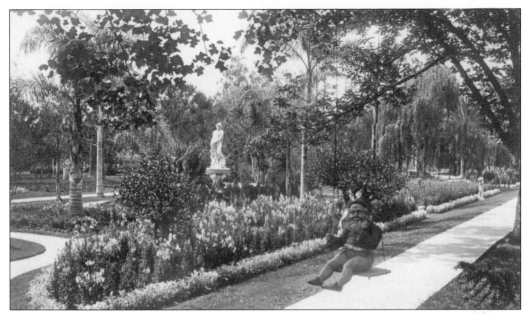

A garden gnome swings from a tree in the fanciful Victorian garden between 8 and 10 Chester Place, and a statue of Diana graces the garden. The meandering walkway was a feature of the formal gardens, where rounding a corner could lead to a new decorative surprise. The curved walks also served as a counterpoint to the straight sidewalks bordering the street. (Sr. Mary Irene Flanagan, CSJ.)

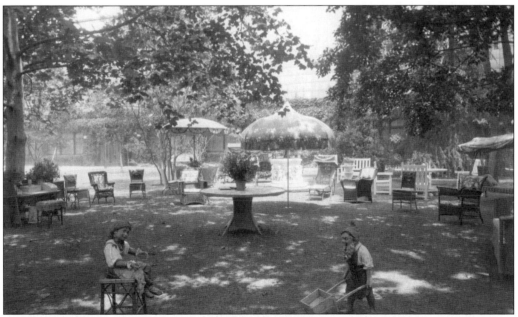

Terra-cotta gnomes are hard at work next to an outdoor umbrella and chairs. The Dohenys embraced the Victorian concept of gardens as "outside parlors" and frequently entertained under the shade of the trees. While many of the ideas were developed in England, the benign climate of Southern California permitted more frequent opportunities for outdoor living. (Sr. Mary Irene Flanagan, CSJ.)

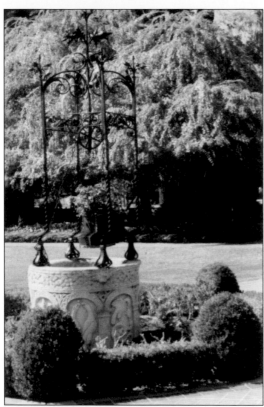

A decorative wishing well occupies the center of the south lawn. Because the Dohenys owned the private street and most of the property by 1915, their staff maintained the sidewalks and planter strips, normally a city responsibility. They also maintained the street. (Sr. Mary Irene Flanagan, CSJ.)

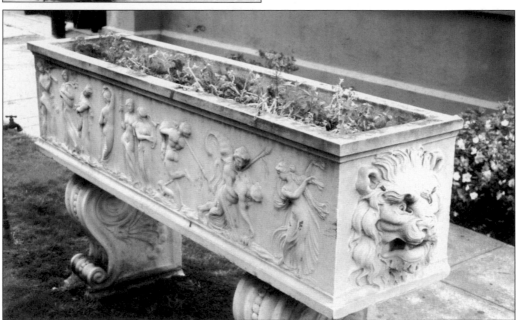

A marble planter guards a walkway. Often planters and urns were not planted with anything but simply set as ornaments to stairs or walkways. During World War II, the Doheny gardeners shifted from seasonal flowers to vegetables. As a result, the gardens furnished the Dohenys, their neighbors, and their staff with produce. (Frank Damon.)

Each year, new lawns were planted. Recalling his work on the estate, Johann Scherer, one of Estelle Doheny's groundsmen, recounted, "Then, men loved their work and no effort was too great in order to please." While no one could pick flowers, Estelle had commercially grown cut flowers delivered to Chester Place twice a week. (Sisters of St. Joseph of Carondelet.)

One of gardener Johann Scherer's most vivid memories is of a cross of lilies that was planted each year on the front lawn of the Doheny mansion during the Easter season. Those who knew her said Estelle knew precisely what she wanted. (Sr. Mary Irene Flanagan, CSJ.)

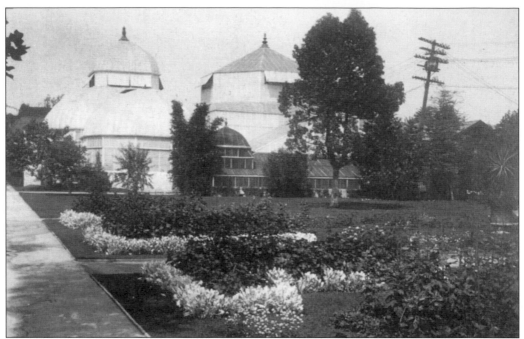

Behind 1 and 7 Chester Place, the Dohenys erected a large greenhouse to supply flowers and other plants for the exclusive enclave. A separate conservatory was built behind the Doheny mansion for the family plant collections. Seventeen men worked as gardeners, with four assigned to the greenhouse, where they raised seasonal bedding plants. As a result, Chester Place became a lush, fragrant garden. (AALA.)

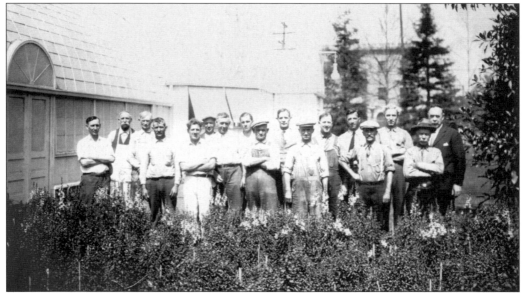

Called "Nick" by Estelle Doheny, Trifone Nicassio stands in the center of the landscaping staff outside the greenhouse. The Italian immigrant's specialty was taking care of palm trees. The Dohenys also sent him to work at Greystone, their son Ned's magnificent home in Beverly Hills. In the background of the photograph is an apartment building at 801 West Twenty-third Street. (Courtesy Nicassio family.)

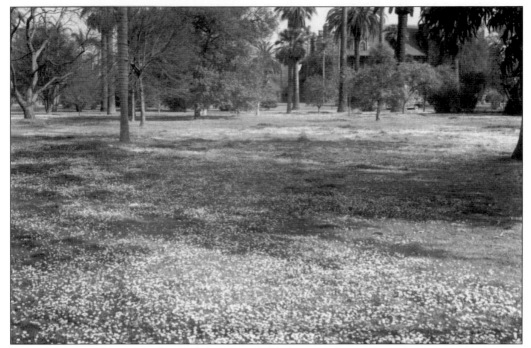

In neat penmanship on the back of this daisy field photograph, Estelle Doheny wrote that it was "taken across the street from my house—which can be seen in upper right corner—All the dark places are shadows." According to William H. Blundell, supervising engineer for the Chester Place grounds, the gardeners were not allowed to mow parts of the lawns to give English daisies an opportunity to bloom. (AALA.)

A lone sprinkler waters the broad lawn to the north of 8 Chester Place. During the Victorian era, it was typical to have at least one large expanse of lawn to provide an impressive view of the house unobstructed by trees or gardens. For other areas, Paul Regling, a 24-year member of the gardening staff, estimated that 100,000 plants were grown each year for replanting. (Robinson Collection.)

Behind the tree limb is the Wigwam Room, which was completed in 1905. The carriage house, with its wide door, is to the right. The Wigwam Room contained a bowling alley, shooting range, large fireplace, and a décor that included animal skin rugs, dark wood paneling, and wooden floors. The room was a favorite location for Edward Doheny to entertain his friends. (Frank Damon.)

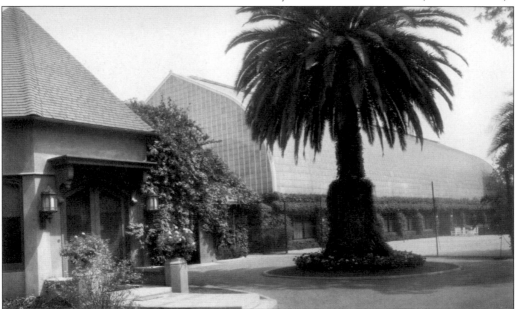

In 1913, a 200-foot-long conservatory designed by Alfred Rosenheim and estimated to cost $150,000 was erected behind the mansion to hold Edward Doheny's collection of palm trees. At left is the Wigwam Room, with the vegetation-covered carriage house between it and the new conservatory. Rosenheim was a noted Los Angeles architect whose work included the Second Church of Christ Scientist, at West Adams Boulevard and Hoover Street. (Sr. Mary Irene Flanagan, CSJ.)

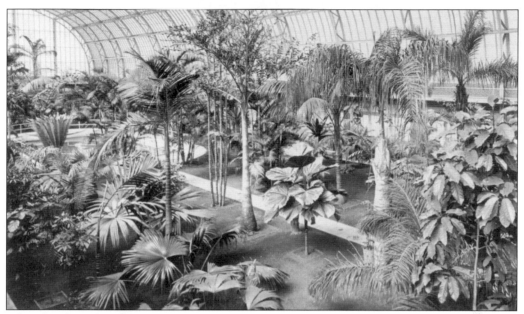

Edward Doheny bought many of his first palms from Edward Howard, who scoured the United States in his search. Doheny then sent Howard south, where he spent from 1907 to 1914 searching for palms in Mexico, Guatemala, and Cuba. Louis Sanders, the prominent English nurseryman, visited and declared that the Dohenys had the finest greenhouse collection in the world. During his retirement, Doheny would visit his conservatory daily. (Sr. Mary Irene Flanagan, CSJ.)

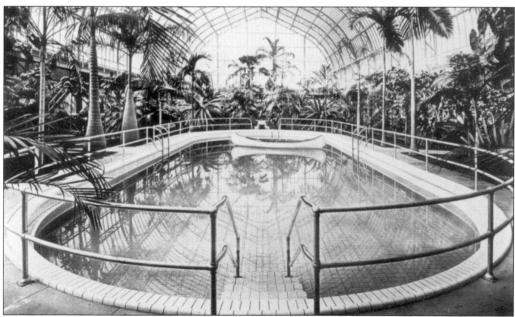

At the center of the conservatory was a swimming pool, complete with canoe. The tropical interior suited orchids, and Estelle Doheny used the encircling balcony to grow more than 5,000 orchids, many imported from England. Employee Paul Regling recalled that he was sent several times to buy hundreds of dollars worth of orchids to add to the collection. (Sr. Mary Irene Flanagan, CSJ.)

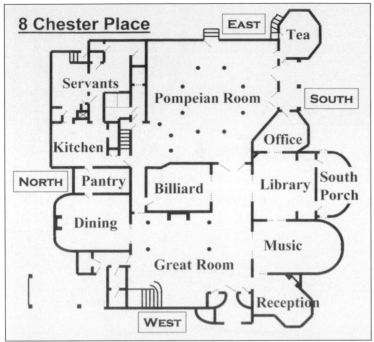

8 Chester Place

EAST

Tea

Servants

Pompeian Room

SOUTH

Kitchen

Office

NORTH | Pantry

Library | South Porch

Billiard

Dining

Music

Great Room

Reception

WEST

The first floor of 8 Chester Place contains the major public rooms of the mansion. The servants' quarters in the northeast corner contains the kitchen, porch, butler's pantry, servants' dining room, and the back stairs. The Great Hall contains a sweeping staircase that leads upstairs to the family rooms on the second floor. The third floor contains an office, a small ballroom, the chapel, and the servants' quarters.

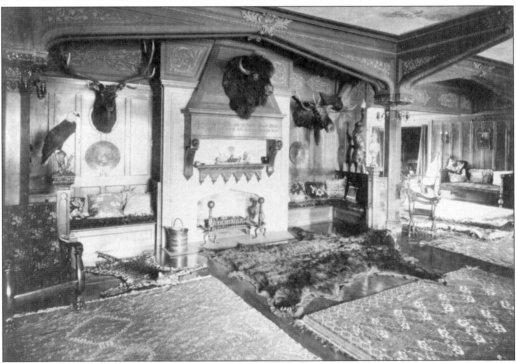

The mansion's evolution is apparent in changes over the years to the Great Hall fireplace. Originally decorated in hunting-lodge style by the Poseys, the room had heavy oak paneling and pillars. Cherubs daintily adorned the ceilings. A large bear rug with claws, head, and open jaws lay in front of the fireplace, and buffalo, moose, and elk heads graced the walls. (Sr. Mary Irene Flanagan, CSJ.)

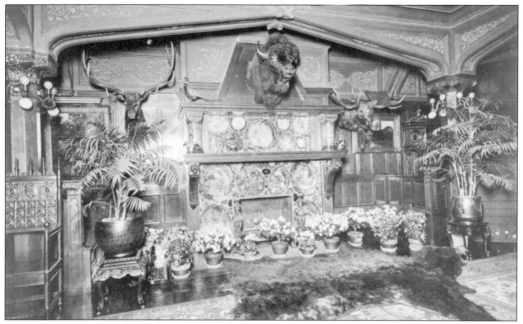

For the first 32 years, the Dohenys made little change to the Poseys' interior décor. In 1912, they installed a polished, petrified-wood fireplace in magnificent hues of maroon, with touches of grey, blue, and white. The fireplace was created by famed architect Stanford White for the Paris Exposition of 1900 and purchased by Edward Doheny because of the rustic Southwestern beauty of the petrified wood. (Sr. Mary Irene Flanagan, CSJ.)

Severe damage from the March 10, 1933, Long Beach earthquake caused major changes to the house, which are still reflected today. Architect Walter Neff redesigned the interior in the more formal Georgian style. A Sienna-marble fireplace was carved in place by Joseph Conradi, a Los Angeles master craftsman who was a native of Switzerland. Marble columns with steel cores replaced the room's wooden columns. (Sr. Mary Irene Flanagan, CSJ.)

The 6.3 earthquake rocked the house at 5:55 p.m., as the Dohenys were having dinner in the dining room, still decorated with paintings by Sara Posey. Estelle Doheny called her staff, and in short order, a convoy of automobiles was headed to the Dohenys' country home in Santa Paula. The Dohenys hired architect Walter Neff to repair their mansion and moved to 649 West Adams Boulevard to supervise. (Sr. Mary Irene Flanagan, CSJ.)

After the earthquake, the McNeil Construction Company began complete reinforcement of the house, placing concrete pillars and beams in the basement to hold up the upper floors' steel supports. Under Estelle Doheny's constant urging, the work on the house was completed in six months. While the original 1900 house was severely damaged, the 1906 Pompeian Room, atop a newer basement, withstood the quake. (Sr. Mary Irene Flanagan, CSJ.)

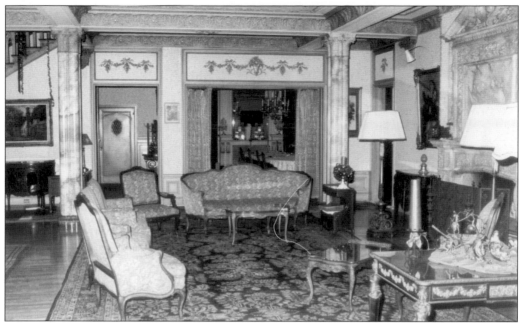

After 1933, the Great Hall featured plaster moldings depicting swags of fruit, with spots of 24-karat gold leaf bordering the ceiling. Estelle Doheny selected the molding. But after it was installed and the gold leaf applied, she did not like the appearance and had it torn out—twice. The present molding is the third version installed. (Sr. Mary Irene Flanagan, CSJ.)

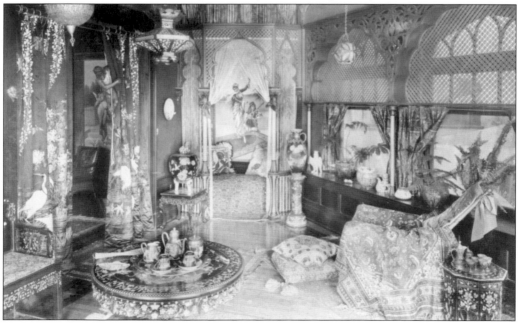

In the late 1800s, it was fashionable for wealthy Victorian homes to have a small Oriental room where exotic objects of fancy could be displayed. The Dohenys had a mixture of objects from Native Americans, as well as from China, Japan, and Persia. The windows of the room looked out onto the Palm Court. Later this was a smoking room, then an office. A toilet room was in the corner. (Sr. Mary Irene Flanagan, CSJ.)

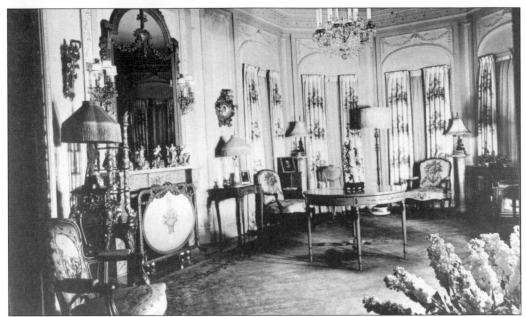

On the first Wednesday of the month, the Dohenys were "at home" to visitors and received them in a Reception Room in the southwest corner of the house. The oddly shaped room had an Aubusson rug woven to fit the room. Like most principal rooms in the house, it had a fireplace. (Sr. Mary Irene Flanagan, CSJ.)

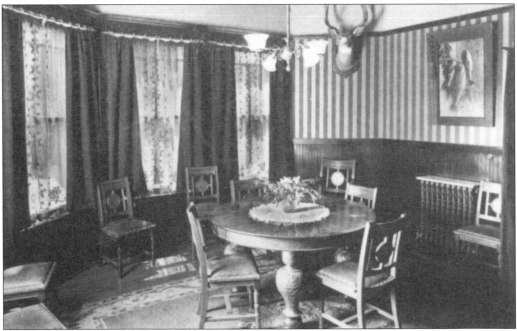

The breakfast nook occupied a relatively small niche overlooking the patio near the kitchen, with windows that caught morning sunshine from the patio. After 1906, this room became an alcove in the northwest corner of the Pompeian Room, with ornate marble columns replacing the former bearing walls. The staff ate in a large room behind the kitchen. (Sisters of St. Joseph of Carondelet.)

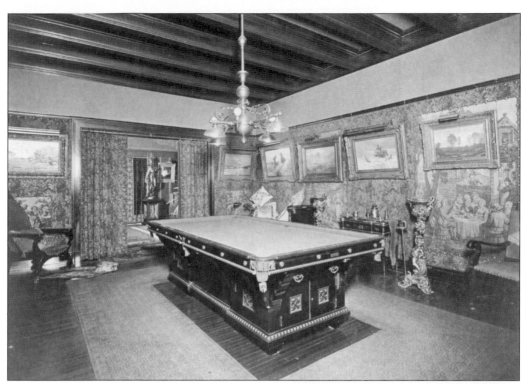

The Billiard Room, above, with its large table, was finished in handsome burl redwood paneling, each piece selected from a grove in Oregon and finished in a high polish, like a fiddle. After 1906, the room's marble-framed windows looked out onto the Pompeian Room. The room has had several names over the years. It became the Ship Room after a model of the Mexican petroleum tanker, the SS *Edward L. Doheny*, shown at right, was placed against the west wall. Later the room was used for some of Estelle Doheny's books. Today it is known as the art gallery and contains paintings by noted Spanish artist Jose Drudis-Biada (1890–1985), which were donated to Mount St. Mary's College. Drudis-Biada's design instructor was Pablo Picasso. (Sr. Mary Irene Flanagan, CSJ.)

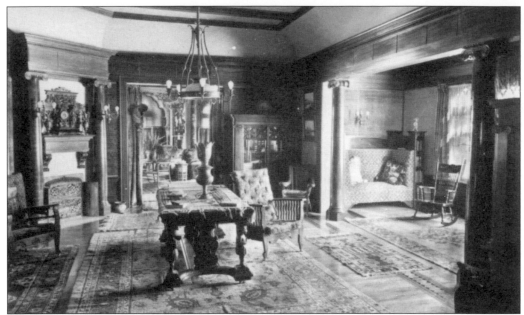

The Library housed some of the rare books that Estelle Doheny collected from 1930 to 1958. At right, two doors lead to the south porch where Edward Doheny spent time during his declining years. A one-way mirror between the doors allowed servants to discretely check on his well-being. In addition to books, Estelle collected many objets d'art, including fans, paperweights, and Currier and Ives prints. (Sisters of St. Joseph of Carondelet.)

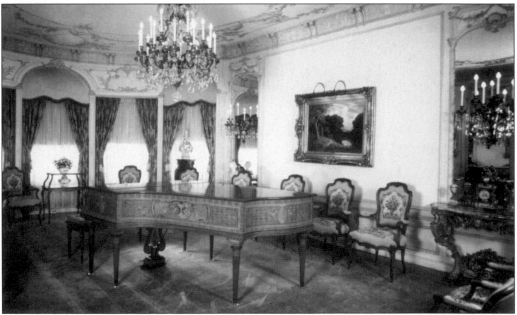

The Music Room is one of the most sumptuous and beautiful spaces in the mansion. Its gold-leafed spotted cornice molding is adorned with relief images of musical instruments. A Pleyel, Lyon, and Cie piano, built in Paris in 1912, features an art case of exquisite marquetry. This instrument replaced a 1905 Steinway, which was donated to the library at St. John's Seminary in Camarillo. (Sisters of St. Joseph of Carondelet.)

The Pompeian Room features a colorful marble floor and pillars and a golden glass dome by Louis Comfort Tiffany. The 24-foot-wide dome contains 2,836 pieces of his patented Fabril glass. Tiffany, the son of the founder of Tiffany and Company, was a well-known painter before experimenting with glass. His domes are rare; he is best known for his lamps. (Sisters of St. Joseph of Carondelet.)

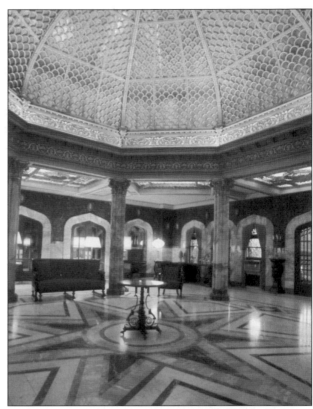

At Christmas time, the family and staff helped decorate a tree in the Pompeian Room. In keeping with the house's original hunting-lodge décor, the tree pictured here is surrounded by animal-skin rugs. A 20-foot-high tree was placed under the dome. In 1931, the tree was decorated entirely in red and silver. Another year, it was decorated entirely in gold tinsel. (Sisters of St. Joseph of Carondelet.)

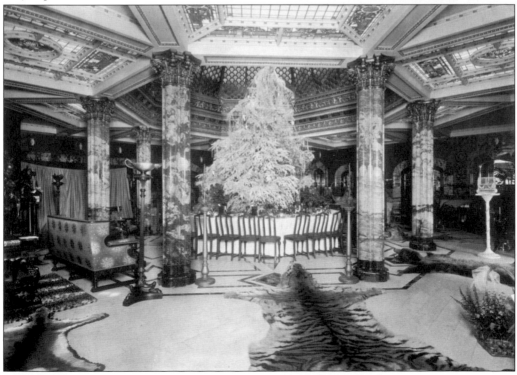

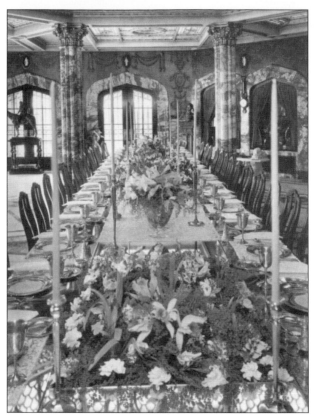

For dinners and gala events, a specially designed mirrored table can be set up in the Pompeian Room. Dinner guests could look down at the table and see the golden Tiffany dome and stained-glass ceiling reflected from above. A fountain could be set up in the middle of the table. Depending on the event, Estelle Doheny would use gold or silver plates and utensils. (Sr. Mary Irene Flanagan, CSJ.)

On the second floor was the family room, also known as the Indian Room. In it, a mural depicts the history of the United States up to Edward Doheny's striking of oil in Los Angeles in 1893. Detlef Sammann, a German painter, started the mural but quit abruptly. Charles Russell, a noted western painter, completed the painting, squeezing the oil strike into a small space at the end. (Sisters of St. Joseph of Carondelet.)

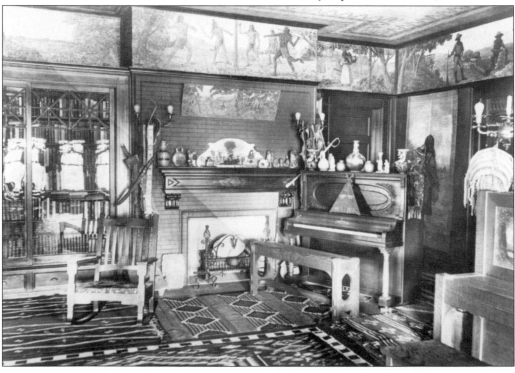

Three

THE DOHENY FAMILY

In 1901, Edward L. Doheny and his wife bought 8 Chester Place. By 1958, when his widow, Estelle, died, the family owned the entire subdivision, as well as many surrounding properties.

Edward Doheny was born August 10, 1856, in Fond du Lac, Wisconsin, to an Irish immigrant father and a first-generation Irish mother. He arrived in Los Angeles in 1891 at the urging of his one-time prospecting partner, Charles A. Canfield, who moved to California after striking a rich lode of silver in New Mexico. Doheny was unsuccessful as a prospector for precious metals, but in 1892, he switched to oil, digging the first successful well in the city of Los Angeles a few blocks west of downtown. His timing was perfect. He started production during the beginning of a paradigm switch in the world's fuel of choice from "king coal" to petroleum. Doheny became a rich man.

In 1892, during the digging of his first well, Doheny's daughter, seven-year-old Eileen, died of heart disease leaving his wife distraught and increasingly unstable. But on November 6, 1893, nearly a year after his daughter's death, Edward's wife, Carrie, gave birth to a son and his only heir, Edward L. Doheny Jr., known as Ned. But a son could not save their marriage, and in 1899, Carrie left for San Francisco and started divorce proceedings.

In 1900, Edward negotiated rights to a half-million acres of oil-producing land in Mexico, which catapulted him from being rich to being fabulously wealthy. Closer to home, he met and married telephone operator Carrie Estelle Betzold, whose voice on the line had won him over. Edward was 44, and she was 25. His new wife stopped using her first name and was known as Estelle Doheny.

Edward's first wife died within a month of his marriage to Estelle, in August 1900, and Estelle became mother to seven-year-old Ned. Ned grew up on Chester Place, married, and had five children before moving to his new estate, Greystone, in Beverly Hills in November 1928. Three months later, Ned was murdered by an employee. After his son's death, Edward was a broken man, dying at 79 years of age in his mansion at 8 Chester Place in 1935. Estelle continued to consolidate their holdings in the Chester Place neighborhood until her death in 1958 at the age of 83.

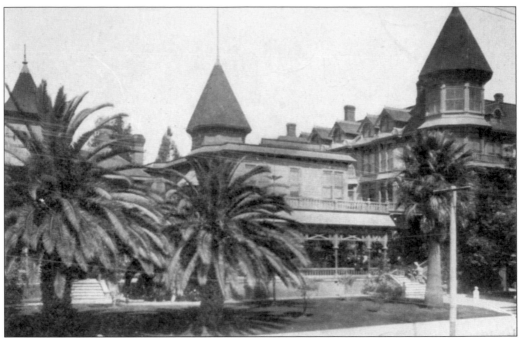

In 1892, Edward Doheny and his family lived at the Bellevue Terrace Hotel on Sixth Street, one block west of Figueroa Street. Doheny later said he decided to dig for oil after seeing a wagonload of "brea," or tar, pass the hotel's porch as it was being delivered for fuel. At the time, a limited amount of oil was being produced and refined in Ventura County. (Robinson Collection.)

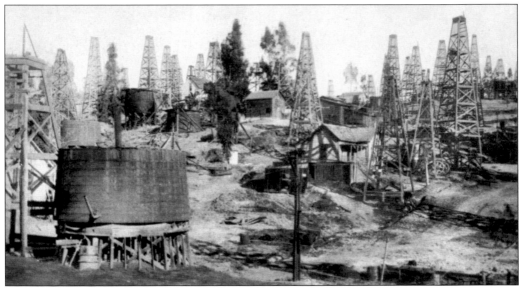

The Los Angeles oil field was discovered by Doheny and his partner Charles Canfield after they leased property near the present-day Glendale Boulevard and First Street and dug a well 155 feet. Stopped by deadly fumes, they rigged a crude drill, went 20 more feet, and hit oil. At the time, digging for oil was not unheard of, but it soon gave way to drilling. (Connie Rothstein Collection.)

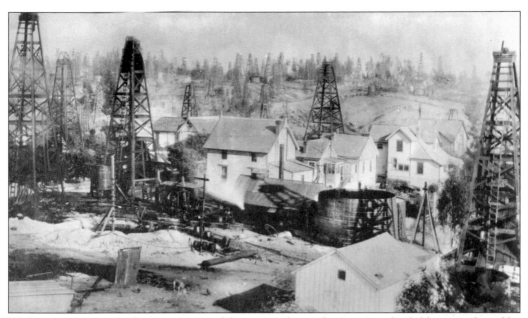

With no restrictions, oil pumps sprouted from every lot as the Los Angeles field was exploited by a variety of owners. The field was in a residential neighborhood immediately west of downtown Los Angeles. Above is the corner of First and Belmont Streets, later the site of the Los Angeles Unified School District's ill-fated Belmont Learning Center. (Connie Rothstein Collection.)

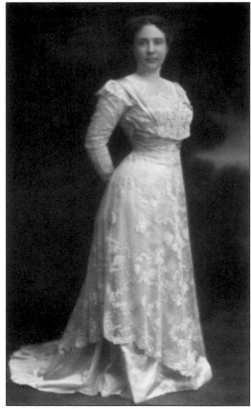

In 1900, Carrie Estelle Betzold was a telephone operator for the Sunset Telephone and Telegraph Company who placed some of Doheny's calls to raise money for his Mexican venture. He liked the sound of her voice on the telephone, and they soon met and fell in love. Her father, John E. Betzold, was a streetcar conductor who had moved west after her birth on August 2, 1875, in Philadelphia, eventually settling in Los Angeles. (AALA.)

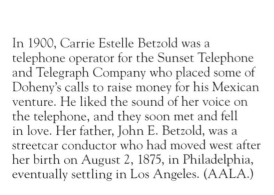

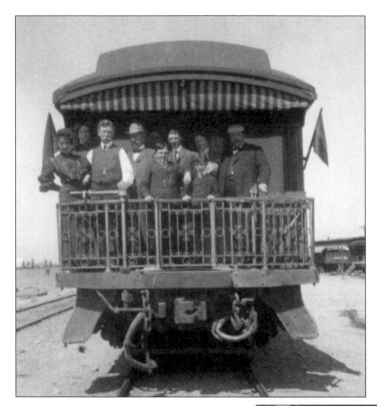

A justice of the peace married Carrie Estelle Betzold to Edward Doheny on August 22, 1900, aboard a private railroad car on a siding in Albuquerque, New Mexico. In the front row, from left to right, are Estelle, Edward, Albert Canfield, and Edward "Ned" L. Doheny Jr. Estelle was a Methodist, and Edward was a Catholic. (AALA.)

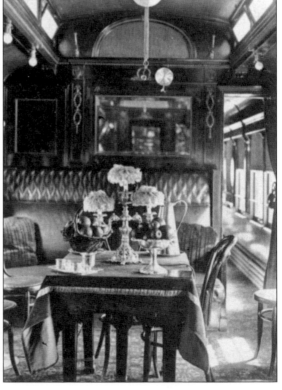

Edward Doheny's railcar, rechristened the "Estelle" after his marriage, was outfitted with black walnut paneling and included a kitchen and dining area. He lived in the private car for extended periods, conducting business, particularly concerning his Mexican oil interests, during the first years of his marriage. (Mount St. Mary's College.)

This railcar was Edward and Estelle Doheny's first home, and they kept it for 30 years. A hand-cranked record player in the drawing room offered entertainment. It was decorated with plush carpeting, chandeliers, and French mirrors. Because the Dohenys had few household possessions, they purchased 8 Chester Place fully furnished. (Mount St. Mary's College.)

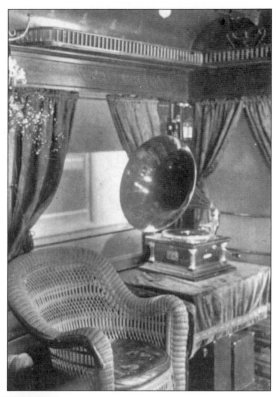

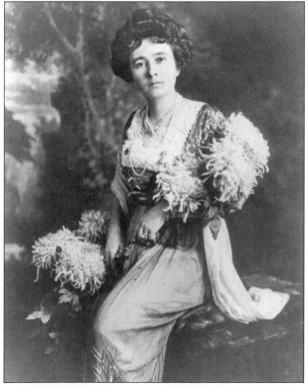

At her new mansion at 8 Chester Place, Estelle Doheny often found herself alone, as Edward spent years in Mexico conducting his business. When he did return to the United States, they often traveled to New York, Washington, D.C., and other Eastern cities as he sought the massive capital required for his business.

Edward Doheny stands in his oil camp at Ebano, Mexico, during the early days of his Mexican exploration. At first, his wells produced a heavy tar more suitable for low-priced asphalt than for higher-priced engine oil and gasoline. This discouraged investors, and Doheny had to commit increasing amounts of his own money to keep the operation afloat. (AALA.)

Charlie Canfield had been partners with Edward Doheny in mines in New Mexico before Canfield struck it rich with his own silver mine and moved to Los Angeles in 1886. He urged Doheny to follow him, but by the time Doheny arrived, five years later, Canfield was broke. He became Doheny's partner in his Los Angeles oil well in 1892 and in the development of the Mexican oil fields.

The president of the Mexican Central Railway noticed natural gas bubbling through puddles of oil during the railroad's construction near Tampico on the Gulf Coast in 1900. Edward Doheny sized up the potential, raised capital, and sought approval to develop the field. He was welcomed by Mexican president Porfirio Diaz, who understood the vast capital investment required.

One of Edward Doheny's road-building crews clears a path for oil exploration in Mexico. Doheny's most difficult challenge was raising the money for the required infrastructure, including roads, pipelines, oil tanks, worker housing, port facilities, and oceangoing ships. Even with oil in hand, Doheny had to develop a marketing organization to find willing buyers.

Edward Doheny, dressed in a dark suit, stands among his managers in Mexico. Doheny formed the Pan American Petroleum Company in 1916 as a holding company that controlled Mexican Petroleum Company, Huasteca Petroleum Company, and other subsidiary companies that produced, transported, and sold his oil. Doheny was among many oilmen seeking rights in Mexico, but he was greeted favorably by Mexican president Porfirio Diaz, who was suspicious of Doheny's rival, John D. Rockefeller. (AALA.)

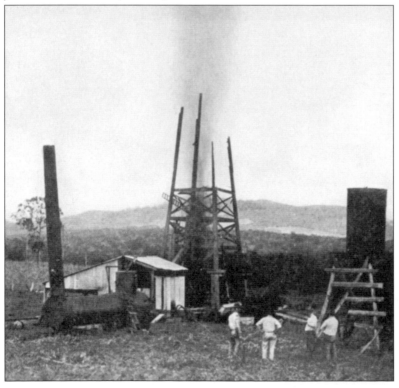

The oil well that single-handedly ensured Edward Doheny's financial success in Mexico, "Cerro Azul," or "blue hill," No. 4, erupted February 10, 1916, when natural gas blew huge, two-ton drilling tools 120 yards away and reduced the upper part of the derrick to kindling. The saver valve to control the flow was torn completely away. Later, oil shot 598 feet in the air, and the flow on February 11 reached 260,858 barrels a day.

The company's master mechanic devised a valve, and on February 19, 1916, it was carefully worked over the casing in the open position. Once it was locked in place, the valve could be closed, bringing the well under control. By December 31, Cerro Azul No. 4 had produced an unbelievable 57,082,755 barrels of oil. Edward Doheny's risky investment had paid off.

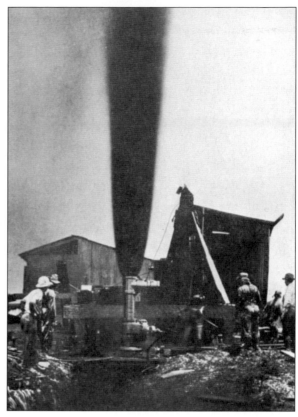

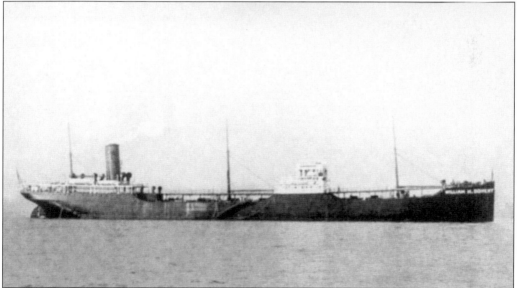

By 1921, the *William H. Doheny* was one of 31 oil tankers owned by Doheny's Pan American Petroleum and Transport Company. Five were named for residents of Chester Place. Four were Dohenys: Edward, Ned, and grandsons William and Larry. One was named for his Mexican operations manager, Herbert J. Wylie, who lived at 17 Chester Place. The SS *Larry Doheny* was torpedoed and sunk in 1942 by a Japanese submarine off the coast of Oregon.

In 1906, Chloe Canfield, the wife of Edward Doheny's longtime partner, Charles Canfield, was murdered in Los Angeles by a discharged family coachman. Estelle Doheny, who befriended Chloe while their husbands were in Mexico, went into mourning. Canfield rushed home and never returned to Mexico. The coachman, found hiding in the Westlake Park boathouse, was hanged in 1907 at San Quentin. (AALA.)

Estelle and Edward Doheny sit at the center table during a July Fourth celebration in the patio behind their home at 8 Chester Place. The patio tile was imported from the Alhambra in Spain and contained brilliant rust, green, and yellow colors. In 1906, the patio was replaced, and today the windows behind the Dohenys look into the Pompeian Room.

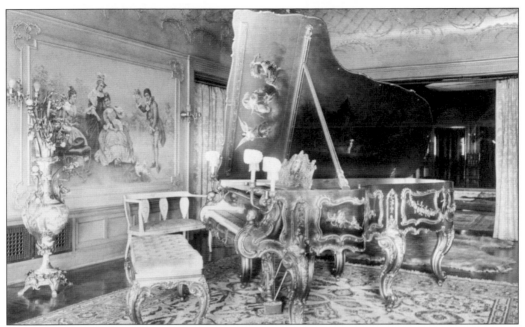

A gold-lacquered Steinway piano was Edward Doheny's gift to Estelle for her birthday in 1905. A painting by Edward Dowdall under the lid depicts Estelle dressed in white, standing in front of 8 Chester Place. Busts of Ned Doheny are at each end of the keyboard. The music room in 1905 was more formal than the mansion's other main rooms, which had a hunting-lodge style. (Sr. Mary Irene Flanagan, CSJ.)

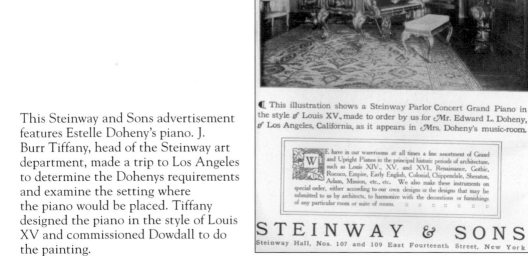

This Steinway and Sons advertisement features Estelle Doheny's piano. J. Burr Tiffany, head of the Steinway art department, made a trip to Los Angeles to determine the Dohenys requirements and examine the setting where the piano would be placed. Tiffany designed the piano in the style of Louis XV and commissioned Dowdall to do the painting.

This illustration shows a Steinway Parlor Concert Grand Piano in the style of Louis XV, made to order by us for Mr. Edward L. Doheny, of Los Angeles, California, as it appears in Mrs. Doheny's music-room.

WE have in our warerooms at all times a fine assortment of Grand and Upright Pianos in the principal historic periods of architecture, such as Louis XIV., XV. and XVI., Renaissance, Gothic, Rococo, Empire, Early English, Colonial, Chippendale, Sheraton, Adam, Mission, etc., etc. We also make these instruments on special order, either according to our own designs or the designs that may be submitted to us by architects, to harmonize with the decorations or furnishings of any particular room or suite of rooms.

STEINWAY & SONS

Steinway Hall, Nos. 107 and 109 East Fourteenth Street, New York

Estelle Doheny's mother, Susan Betzold, stands third from the left on the front doorsteps of 8 Chester Place. Estelle Doheny is to the right of her mother. Estelle kept close ties to her mother and her only sibling, Daysie May Anderson. Her sister's husband, J. Crampton Anderson, worked for Edward Doheny. (Sisters of St. Joseph of Carondelet.)

Estelle Doheny was a Methodist, but after her marriage, she became interested in the Catholic Church. She took instruction from Rev. Joseph S. Glass, C. M., pastor of St. Vincent's Church, from 1901 to 1915. Estelle was baptized in the Catholic Church on October 25, 1918, at St. Patrick's Cathedral in New York City. Glass became bishop of Salt Lake City. (Sisters of St. Joseph of Carondelet.)

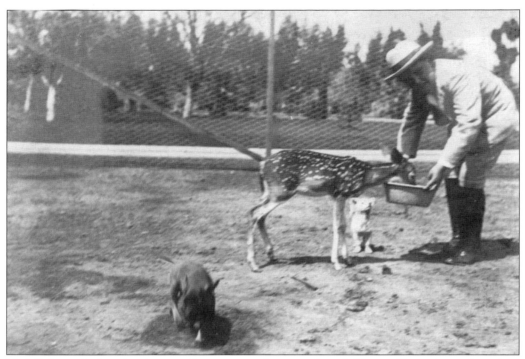

Ned Doheny feeds a deer in a small zoo across the street from 8 Chester Place. A nearby aviary contained a variety of birds. Estelle kept a large sack of chestnuts to feed squirrels that thrived in the foliage of the neighborhood. Squirrels still scamper through the property but are no longer treated to chestnuts. (Mount St. Mary's College.)

Young Ned Doheny sits behind the wheel, pretending to drive one of his father's automobiles in the driveway outside the dining room windows at 8 Chester Place. Estelle Doheny is in the back seat. Edward Doheny favored Pierce-Arrow automobiles, and at one point, he owned six of the luxury cars, which were kept in the carriage house. (AALA.)

Ned Doheny joined the navy as a lieutenant in 1917, as the United States prepared to enter World War I. His first commanding officer was Frank Seaver, whom he had met in Los Angeles through their shared interest in aviation. The previous year, Ned had graduated with a bachelor's degree in mathematics from the University of Southern California. (Sisters of St. Joseph of Carondelet.)

Lucy Marceline Smith, shown on her wedding day, married Ned Doheny on June 10, 1914, while Ned was a student at USC. Lucy was the daughter of William Henry Smith of South Pasadena, a vice president of the Pasadena trolley company. After a honeymoon in New York, they took up residence at 8 Chester Place, where their only daughter, Lucy Estelle, was born on June 21, 1915. (AALA.)

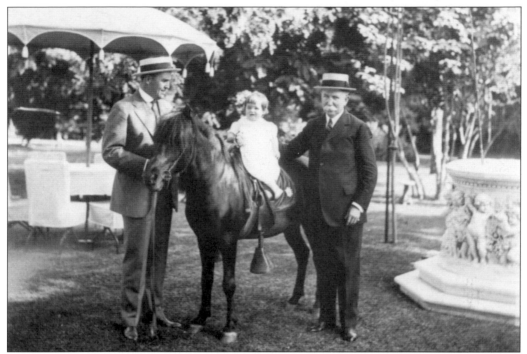

Three generations of Dohenys pose next to the wishing well in the south gardens of 8 Chester Place. Ned stands to the left of his daughter, Lucy, who is astride a pony. Edward stands to the right. Ned and Lucy had four additional children, all boys: Edward, February 8, 1917; William, March 12, 1919; Patrick, June 11, 1923; and Timothy, April 5, 1926. (Mount St. Mary's College.)

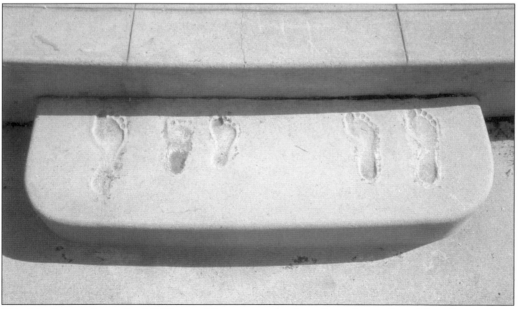

Outside the south porch of 8 Chester Place, a step leads up from the garden. After the concrete was poured, the five Doheny grandchildren each placed a foot in the step. Their footprints remain as a reminder of the happy days, when the sound of children playing echoed from their home at 10 Chester Place across the broad lawns to their grandparents' mansion next door.

In November 1921, Edward Doheny loaned $100,000 in cash to an old friend from his prospecting days in New Mexico, Albert Fall, secretary of the interior. Ned Doheny and his assistant, Hugh Plunkett, traveled to the East Coast to deliver the money. Fall had taken over responsibility for the U. S. Naval petroleum reserves from the secretary of the navy. (Sisters of St. Joseph of Carondelet.)

The public was outraged after discovering that Harry Sinclair of Salt Lake City–based Sinclair Oil had provided money to Interior Secretary Fall before receiving permission to drill on Tea Pot Dome, a naval oil reserve in Wyoming. In the ensuing investigation, Doheny revealed his loan to Fall, made before winning a bid to drill on naval reserve land in California. All were indicted in a lengthy process called the Tea Pot Dome scandal.

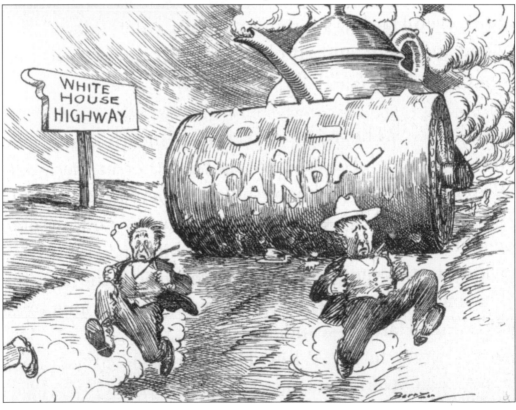

On April 1, 1925, Edward Doheny, 69, sold his Mexican oil interests to Standard Oil of Indiana. He was questioned for selling the property at a bargain, but proved astute by doing so before the Great Depression and Mexico's expropriation of foreign oil interests. But he remained liable in the continuing Tea Pot Dome investigations. (Sr. Mary Irene Flanagan, CSJ.)

As the Tea Pot Dome investigations distracted Edward Doheny, his son, Ned, took on a more active role in the business. Diversifying into real estate, he bought beachfront property at Capistrano Beach, California, and built the Capistrano Beach clubhouse, shown below. The area, which has great natural beauty, is between Dana Point and San Clemente.

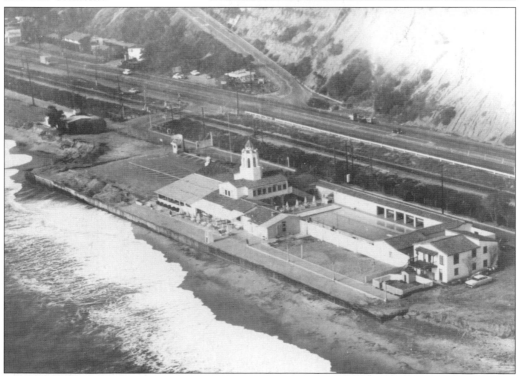

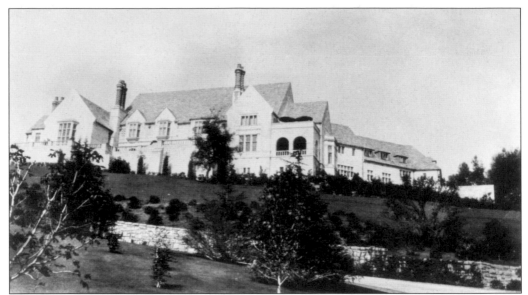

In 1926, Edward and Estelle Doheny sold their 428-acre Doheny Ranch in Beverly Hills to Ned and his wife, Lucy, for $10. Then, they built their son a 46,000-square-foot, 55-room mansion, called Greystone, with commanding views of the Los Angeles Basin. The grounds included riding trails, a waterfall, a 16,000-square-foot stable, and a 10-car garage. The home was completed in November 1928. (Sisters of St. Joseph of Carondelet.)

Designed by architect Gordon B. Kaufman, whose works include the Times-Mirror Building at Spring and First Streets downtown, Greystone had seven Georgian fireplaces, a 30-seat motion-picture theater, a two-lane bowling alley, walk-in fur and jewelry vaults, a billiard room, and a hidden bar. It was considered the finest home in California south of San Simeon. The Dohenys gave Kaufman a new Cord automobile in appreciation of his creation. (Frank Damon.)

Greystone's living room includes a balcony over the living room where musicians could play for guests. Hugh Plunkett, Ned's longtime assistant, was in charge of construction. It was Plunkett who had accompanied Ned to the East Coast to deliver $100,000 in cash for Albert Fall. As the Tea Pot Dome litigation continued, Plunkett exhibited signs of mental instability. (Frank Damon.)

Decorative plaster, richly carved wood, and a slate roof delayed construction and increased the emotional strain on Hugh Plunkett, who was responsible for completion of the huge Greystone project. His wife filed for divorce in 1927, and he worried about being arrested during the coming Tea Pot Dome trials. Over Christmas, in 1928, he suffered what a doctor described as a "nervous breakdown." (Frank Damon.)

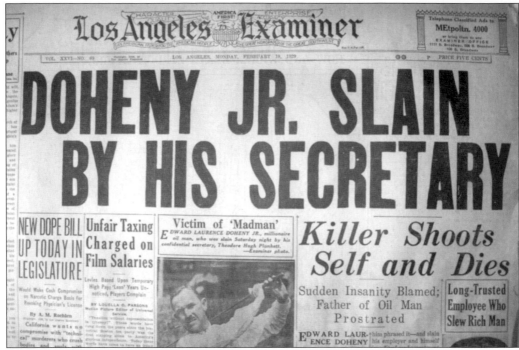

Los Angeles Examiner

VOL. XXVI—NO. 49 LOS ANGELES, MONDAY, FEBRUARY 18, 1929 P PRICE FIVE CENTS

DOHENY JR. SLAIN BY HIS SECRETARY

NEW DOPE BILL UP TODAY IN LEGISLATURE

Would Make Cash Compromise on Narcotic Charge Basis for Revoking Physician's License.

By A. M. Rochlen

California wants no compromise with "technical" murderers who crush bodies and souls with

Unfair Taxing Charged on Film Salaries

Levies Based Upon Temporary High Pays 'Lean' Years Unnoticed, Players Complain

BY LOUELLA O. PARSONS
Motion Picture Editor of Universal Service.

Victim of 'Madman'

EDWARD LAURENCE DOHENY JR., millionaire oil man, who was slain Saturday night by his confidential secretary, Theodore Hugh Plunkett.
—Examiner photo.

Killer Shoots Self and Dies

Sudden Insanity Blamed;
Father of Oil Man
Prostrated

EDWARD LAUR-
ENCE DOHENY

Long-Trusted Employee Who Slew Rich Man

On February 16, 1929, after four months at Greystone, Ned and Lucy Doheny were getting ready for bed when Hugh Plunkett confronted them. Trying to calm Plunkett, Ned led him to a guest room and called a doctor. Before Dr. Ernest Fishbaugh could arrive, Ned was fatally shot. Shortly after Fishbaugh appeared, Plunkett killed himself. The deaths were ruled a murder-suicide.

Dr. Herbert Eaton, founder of Glendale's Forest Lawn Memorial Park, sold the Temple of Santa Sabina, said to have previously contained the second-century martyr's remains, as a memorial for Ned Doheny's grave. The Italian marble monument occupies a prominent intersection at Forest Lawn with a commanding view of the city below. The next day, Hugh Plunkett was buried further down the slope. Ned's grave is unmarked. (Frank Damon.)

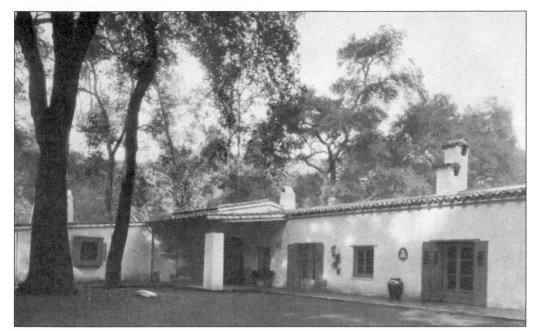

Edward was devastated by Ned's murder. To change his surroundings, Estelle hired architect Wallace Neff to build a ranch house next to a flowing stream on the couple's wooded Ferndale Ranch near Santa Paula. Hundreds of workers rushed to complete the 9,000-square-foot house in less than six weeks, even working at night under lights. It is now on the campus of Thomas Aquinas College. (Mary Baum.)

In 1930, Doheny was acquitted of all charges in the Teapot Dome cases. Albert Fall, the former secretary of the interior, was convicted of bribery for taking Doheny's money. The case led to the popular term "the fall guy." During litigation, Doheny's trial attorney, Frank Hogan, used Doheny's Wigwam Room, at right, as an office. A wooden plaque above the door read, "Hogan's Alley." (Mount St. Mary's College.)

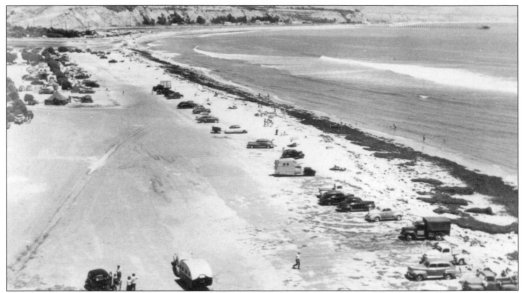

After Ned's death in 1929 and the start of the Great Depression, Edward was in failing health and had little interest in real estate development. In 1931, the Dohenys donated 41 acres of beachfront property at Capistrano Beach to the State of California for Doheny State Beach, dedicated as a memorial to Ned. It was California's first state beach.

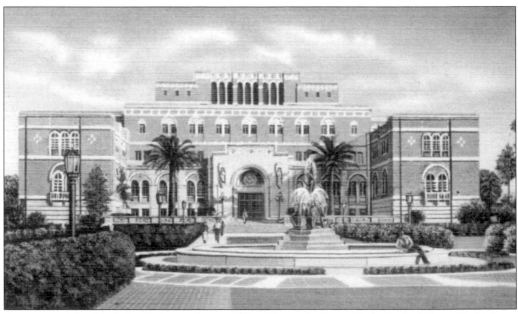

As a memorial to Ned, the Dohenys donated $2 million to build and furnish the Edward L. Doheny Jr. Memorial Library at the University of Southern California. Ralph Adams Cram, who designed the interior of the present St. Vincent's Church, at West Adams Boulevard and Figueroa, was the architect. Ned had been a USC trustee. (Elizabeth Staley.)

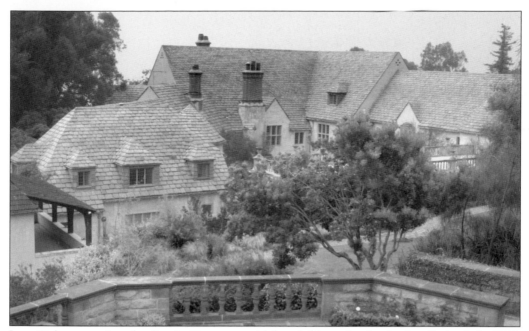

Lucy Doheny continued to live in Greystone with her children after her husband's death. In 1932, she married investment banker Leigh Battson. The grounds outside the house were sold in 1954 to Paul Trousdale, who developed them into the exclusive Trousdale estates area of Beverly Hills. Today the remaining Greystone property is a city park and the site of the city water reservoir. (Frank Damon.)

In the 1930s, Estelle Doheny converted the southwest corner of her Chester Place mansion's third floor into a private chapel. Its altar is from the Barberinis, an aristocratic Italian family. Estelle commissioned the bronze tabernacle door locally. She sat on the board of Pan American Petroleum as one of the first female directors of a major company, a valuable experience as Edward's health declined. (Sr. Mary Irene Flanagan, CSJ.)

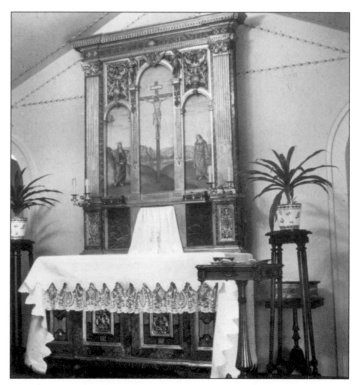

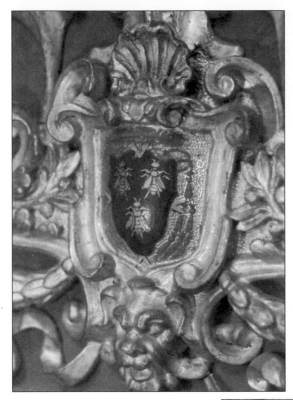

The three bees on an altar panel were from the coat of arms of the Barberini family. Estelle Doheny acquired the altar from Fr. Joseph S. Glass, who was pastor of St. Vincent's Church from 1901 to 1915. She had the panel containing the bees removed when the tabernacle was inserted. (Sisters of St. Joseph of Carondelet.)

Edward and Estelle Doheny sit on the south porch of 8 Chester Place in front of the one-way window that allowed servants to check on Edward's well-being but did not allow outsiders to see inside the house. As Edward's health declined, Estelle took over running the business and their charitable contributions. Edward died September 9, 1935 and left his estate to Estelle. (AALA.)

Some 1,200 people attended Edward Doheny's invitation-only funeral in St. Vincent's Church, and 2,000 gathered outside. After the funeral, Estelle, her sister, and personal secretary burned his personal and business papers. As a result, research became more difficult concerning Edward's vital contribution to the Mexican petroleum industry and his impact upon California and Los Angeles. Today his role is generally unknown. (St. Vincent de Paul Church.)

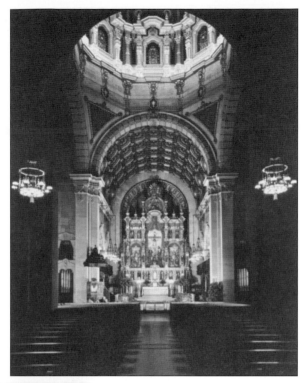

In 1939, Estelle donated the Edward L. Doheny Memorial Library to St. John's Seminary in Camarillo. She turned to her favorite architect, Wallace Neff, who designed a two-story, Spanish Colonial Revival building, completed in 1940. The entrance facade replicated the baptistery of the cathedral in Mexico City. (Mount St. Mary's College.)

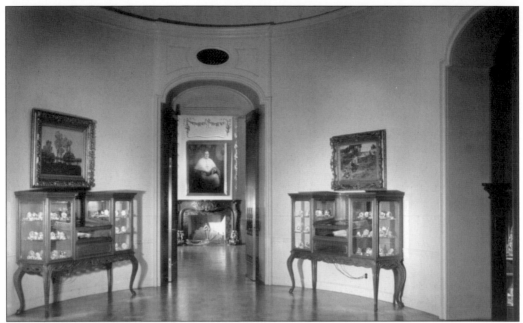

The library's second floor had a Treasure Room for the Dohenys' collections of paintings, objets d'art, and rare books. The art objects, moved from 8 Chester Place, included Estelle's golden Steinway piano, the second-floor murals by noted German painter Detleff Sammann (completed by western artist Charles Russell), the second-floor piano decorated by western artist Edward Deming, and a Gutenberg Bible. (Mount St. Mary's College.)

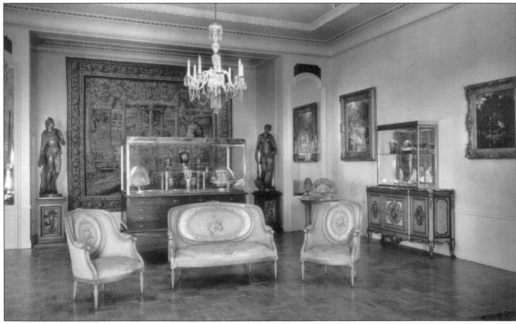

Estelle Doheny personally arranged the Treasure Room exhibits. To establish an endowment for the diocese seminary, the Archdiocese of Los Angeles sold the collection in a series of auctions between 1987 and 1989 for $40.9 million. The Steinway piano with Estelle's portrait on the lid sold for $66,000 in 1988. (Mount St. Mary's College.)

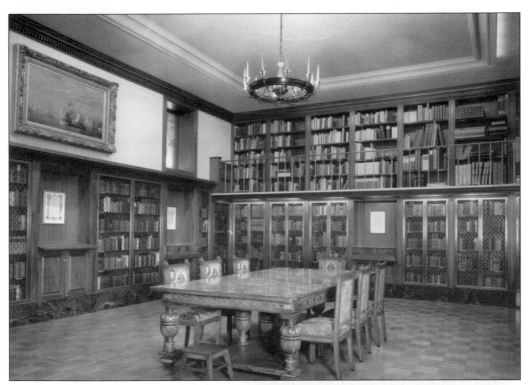

Estelle Doheny's collections included rare books, the signatures of every U.S. president, 138 Currier and Ives prints, and 106 fans. She owned more than 300 fore-edged books, the world's largest collection (paintings appear when fore-edged books are opened and their pages fanned). In 1962, four years after her death, the Carrie Estelle Doheny Memorial Library was constructed at St. John's Seminary. (Mount St. Mary's College.)

A case in the Camarillo library housed part of the Dohenys' extensive collection of antique glass paperweights. Built for the Treasure Room, the case fit precisely against the room's curved wall. Estelle Doheny sent many of her paperweights to the Vincentian order in Perryville, Missouri. (Mount St. Mary's College.)

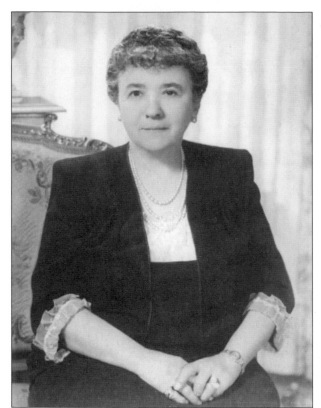

A generous philanthropist, Estelle Doheny was awarded the rare title of papal countess by Pope Pius XII in June 1939. Six years later, in February 1945, the pope approved the holding of services in her chapel on the third floor of the mansion. Until her death in 1958, a priest and altar servers from St. Vincent's Church would offer daily Mass in her private chapel. (Sisters of St. Joseph of Carondelet.)

Estelle Doheny examines her Gutenberg Bible, one of the best remaining copies of the 48 that exist. On August 4, 1944, while praying in her third-floor chapel on her 65th birthday, Estelle suffered a hemorrhage that left her completely blind in her left eye and partially blind in her right eye. Two years later, she established the world-renowned Estelle Doheny Eye Foundation.

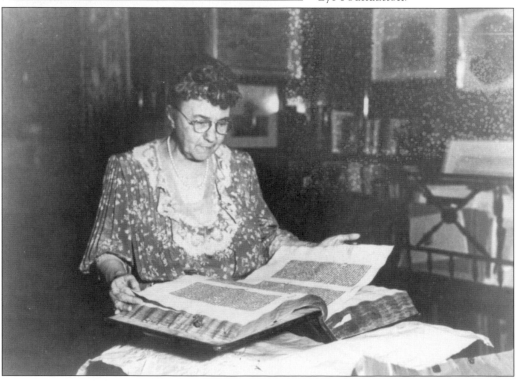

Estelle Doheny sits before the fireplace in the great hall of 8 Chester Place. Her generosity extended to her staff, whom she helped with financial problems and hospital bills. Her staff at the mansion consisted of a cook, a second cook, a relief cook, a kitchen maid, a waitress, a parlor maid, two second maids, a personal maid, a laundress, a seamstress, a cleaning woman, two housemen, three chauffeurs, and three or four secretaries. (Sr. Mary Irene Flanagan, CSJ.)

Estelle Doheny died of heart disease in 1958 at St. Vincent's Hospital and is buried next to her husband in the mausoleum at Calvary Cemetery in Los Angeles. Her will left bequests to 39 charities in amounts up to $250,000 and to 29 family members. An additional 36 paragraphs were bequests to doctors, lawyers, staff, and servants. The rest was left to the Carrie Estelle Doheny Foundation.

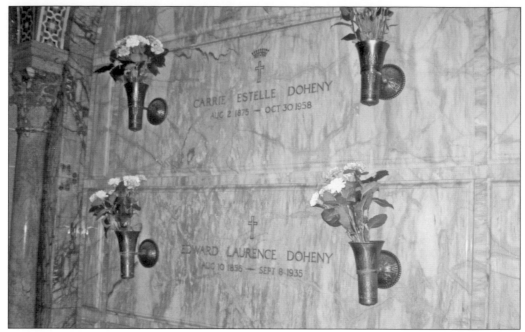

In Calvary's mausoleum, the Dohenys are buried in the first alcove to the right of the altar. Fr. William Ward, the pastor of St. Vincent's Church who frequently celebrated Mass in the Doheny's third-floor chapel, is also buried in the alcove. Ward was a director of the Carrie Estelle Doheny Foundation. Continuing the schedule that Estelle established at Chester Place, fresh flowers are delivered to the graves twice a week.

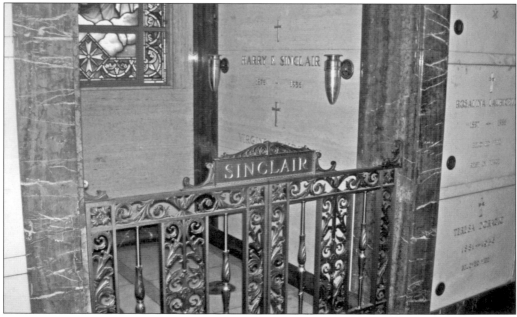

Ironically, Harry Sinclair, whose payment to Albert Fall triggered the Tea Pot Dome investigation, is also buried in the mausoleum at Cavalry Cemetery. In 1949, after 33 years of presiding over the Sinclair Oil Company, he retired to Pasadena, California, where he died in 1956. Sinclair's grave is on a side corridor behind the altar—a good location, but no match for that of the Dohenys.

Four

CHESTER PLACE MANSIONS

All of the mansions on Chester Place today were built and occupied between 1900 and 1903, joining Judge Charles Silent, who subdivided Chester Place in 1899 and who continued to live in the two-story home built by the previous landowner, Nathan Vail. By 1915, 13 mansions graced the exclusive new community. Over time, some of the wealthy newcomers decided their grounds weren't spacious enough, so they bought out their next-door neighbors and razed their homes to create more lawn space.

The first house to be razed was 4 Chester Place, the Vail home, which Judge Silent sold to the Dohenys when he moved to Glendora. The Dohenys demolished it to expand their north lawn. Petroleum executive Herbert G. Wylie, who lived at 17 Chester Place, purchased 19 Chester Place to his south to obtain a more spacious lawn and loggia. To Wylie's north, 15 Chester Place was the next to go. Thus, by the mid-1930s, only 10 mansions remained in the Chester Place enclave.

The nine 100-year-old mansions that survive today make up the Doheny Campus of Mount St. Mary's College. The only home demolished in the past 70 years was 21 Chester Place, razed by the Los Angeles Unified School District, which acquired the property in the 1960s to build Lanterman High School.

By 1958, when Estelle Doheny died, she owned all of Chester Place. The family had moved quickly after buying their mansion at 8 Chester Place, and by 1915, they had bought out most of the neighboring properties. Twenty-fifth Street, which had once run into Chester Place from the west, was purchased by the Dohenys and renamed Chester Place. Houses on both sides of the former Twenty-fifth Street received new addresses, and a third gate was added to separate the enclave from the exclusive St. James Park. These adjustments gave the street its confusing shape—running not only north-south, but also east-west. The home at 15 Chester Place found itself sitting at the corner of Chester Place and Chester Place—an unusual address.

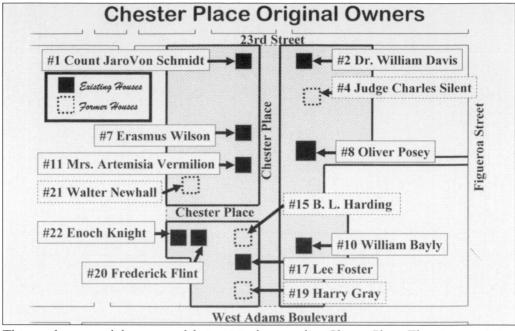

Chester Place Original Owners

23rd Street

#1 Count JaroVon Schmidt

■ Existing Houses
▢ Former Houses

#2 Dr. William Davis

#4 Judge Charles Silent

#7 Erasmus Wilson

#8 Oliver Posey

#11 Mrs. Artemisia Vermilion

#21 Walter Newhall

Chester Place

Chester Place

Figueroa Street

#15 B. L. Harding

#22 Enoch Knight

#10 William Bayly

#20 Frederick Flint

#17 Lee Foster

#19 Harry Gray

West Adams Boulevard

Thirteen houses and the names of their original owners line Chester Place. The nine remaining mansions are shown with solid squares. Ten of the homes were located within Judge Silent's 1899 subdivision, and the three to the west were acquired as Edward and Estelle Doheny expanded their holdings. Four houses on the south side of Twenty-third Street were purchased to make room for a large greenhouse and gardens.

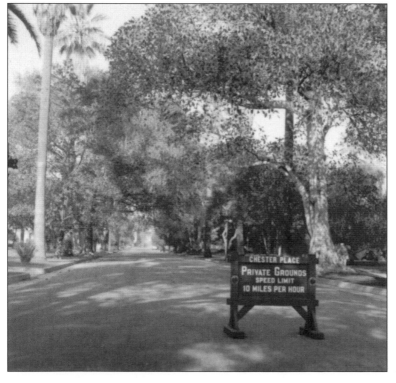

A discreet sign reminding visitors that the private street has a speed limit of 10 miles per hour stands near the West Adams Boulevard entrance to Chester Place in 1958, the year of Estelle Doheny's death. Visitors who parked on the street were approached by the Dohenys' private security guards, who would politely inquire about their business. (Mount St. Mary's College.)

Frank Flint Jr., a prosperous real estate agent and broker, originally owned 20 Chester Place when it was completed in 1902. The architect was Frank D. Hudson. Flint estimated the value of the house at $65,000 for the 1930 census, before selling the property the same year to the Dohenys. The house was immediately rented to Frank Seaver, a senior executive in Doheny's petroleum company. (Mount St. Mary's College.)

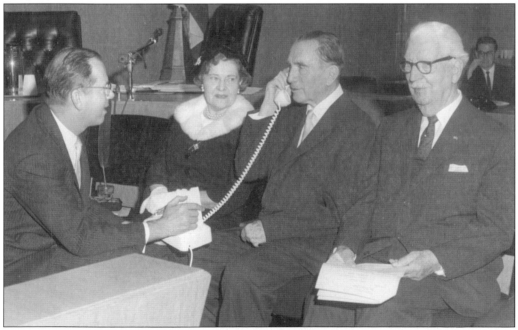

County supervisor Kenneth Hawn (left) watches as Hydril Company president Frank Seaver receives a congratulatory telephone call from California Governor Edmund G. (Pat) Brown in 1962. Also shown are Seaver's wife, Blanche, and his next-door neighbor, USC president Rufus Von KleinSmid, of 17 Chester Place. Fifty years earlier, Seaver, a Harvard-educated attorney, had helped write the Los Angeles County charter. (Pepperdine University Archives.)

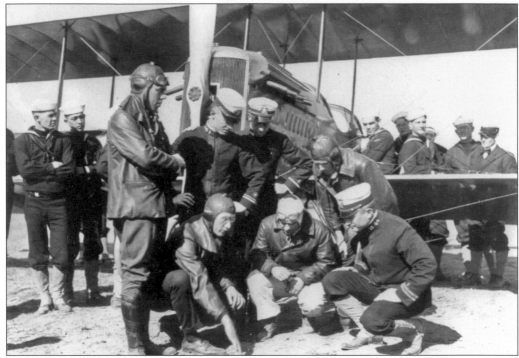

Frank Seaver (right), in his naval lieutenant's uniform, confers with aviation pioneer Glenn Martin and others at a meeting of the aviation section of the California naval militia, which he helped organize. Through the naval militia, he became friendly with Ned Doheny, who shared his interest in airplanes. In 1917, Seaver became Doheny's first commanding officer. (Pepperdine University Archives.)

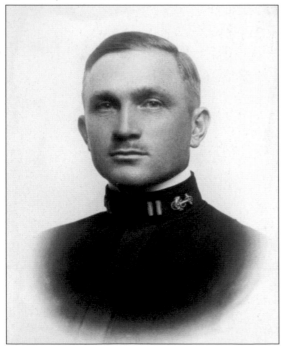

Frank Seaver served on the USS *Pueblo*, and then transferred to New York City where he was in charge of processing discharge papers. Edward Doheny invited Frank and Blanche Seaver to spend a weekend on the Doheny yacht in New York and invited Frank to join his petroleum company when he was discharged. Frank processed his own papers and left the navy the next day. (Pepperdine University Archives.)

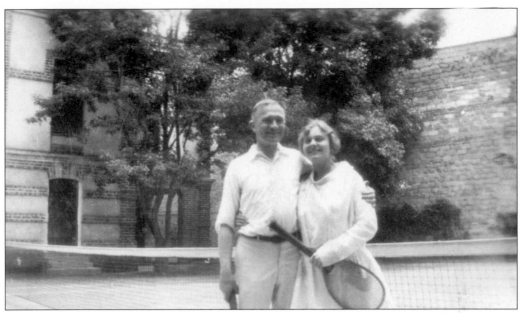

Frank and Blanche Seaver enjoy a game of tennis in Mexico City, where Frank represented Edward Doheny's interests as general manager and vice president of Doheny's Huasteca Petroleum Company. It was a time of political instability, and Doheny's company was Mexico's largest taxpayer. Blanche later recalled a check for $3,059,614 signed by Frank Seaver to the Mexican government for a year's royalty on oil at $1 a barrel. (Pepperdine University Archives.)

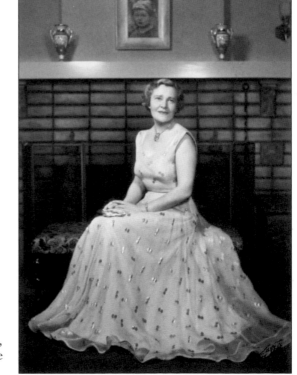

Blanche Seaver, an accomplished musician and composer, sits in front of the fireplace of her home at 20 Chester Place. Frank Seaver served on the Board of Trustees of Mount St. Mary's College, which became his landlord of record after the death of Estelle Doheny. The Seavers were major contributors to Pepperdine University, USC, Loyola Marymount University, Pomona College, and many other institutions. (Pepperdine University Archives.)

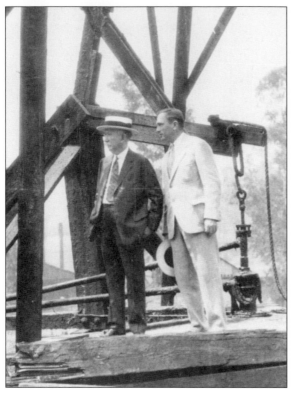

In 1929, Edward Doheny and Frank Seaver stand at the site of Doheny's first oil well during an anniversary ceremony honoring the City of Los Angeles's oil production. A successful businessman in the 1930s, Seaver invested in land, buying 200 acres in Palos Verdes Estates for the amount owned in property taxes to Los Angeles County. The property was later donated as part of Seaver's major financial contribution to build Seaver College, the Malibu campus of Pepperdine University. (Courtesy Pepperdine University Archives.)

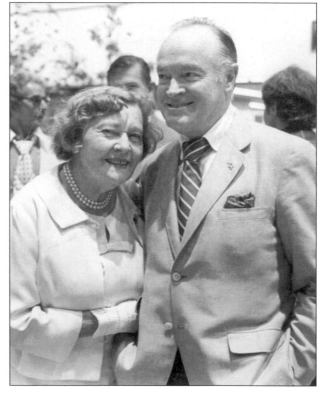

Blanche Seaver celebrates the 1964 opening of the Los Angeles Music Center with comedian Bob Hope. After Frank Seaver's death in 1964, Blanche continued her husband's philanthropy. When she died in 1994 at the age of 103, her monthly rent for 20 Chester Place was $245 a month, which included utilities and gardening. (Pepperdine University Archives.)

When the Dohenys signed this tract map in 1915, they had purchased 14 of the 23 lots in Judge Charles Silent's 1899 subdivision and had bought the street itself from Silent. In addition, they expanded Chester Place by buying property to the west from Twenty-third Street to Twenty-fifth Street, including investor Walter S. Newhall's 2.25-acre lot. Newhall's home became 21 Chester Place. (Los Angeles County Recorder.)

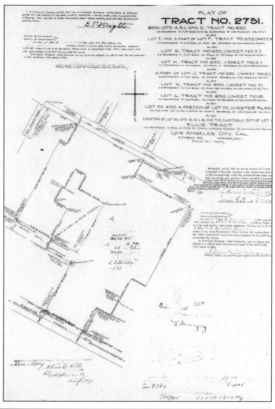

Harry Gray, who owned 19 Chester Place and was a partner in the Barclay-Gray Grocery Company, began construction of the 10-room house next to the West Adams Boulevard gates in September 1900. The building permit estimated the cost of the home to be $13,000. With its towering columns and third-floor cupola, it was an imposing structure on a street of mansions. (Robinson Collection.)

A Brazilian jacaranda tree graces the lawn in front of the two-story pillars of 19 Chester Place. Harry Gray continued to buy property, including one with 121 feet of frontage on Orange Grove Avenue in Pasadena. By 1910, the house was owned by Philip L. Wilson, who occupied it with his wife, daughter, three servants, a cook, and a laborer. (Robinson Collection.)

After 1900, three houses occupied the first block on the west side of Chester Place north of West Adams Boulevard. Looking north are the white-columned pillars of Harry Gray's 19 Chester Place (left), followed by No. 17, and in the distance is No. 15, with its dual broad, sloped roofs. (Marlene Laskey Collection.)

Looking south past a water faucet on the lawn of 15 Chester Place, No. 17 and cupola-topped 19 Chester Place are visible. Within a few years, Herbert George Wylie, the owner of No. 17, had bought and demolished his next-door neighbor's house at 19 Chester Place to expand his south lawn. (Connie Rothstein Collection.)

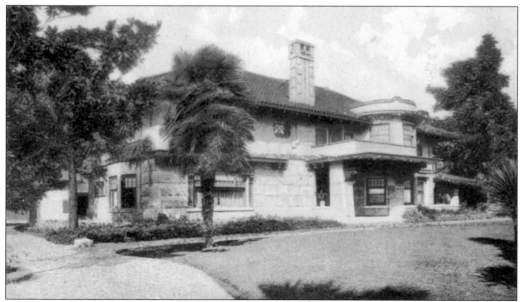

In November 1900, wealthy grocer Lee W. Foster hired the architectural firm of Sumner P. Hunt and A. Wesley Eager to build 17 Chester Place. Foster and his family moved to California from Butte, Montana, to retire. Hunt was also the architect for 8 and 11 Chester Place and nearby 649 West Adams Boulevard. On June 5, 1905, Foster died in his home at the age of 68. (Marlene Laskey Collection.)

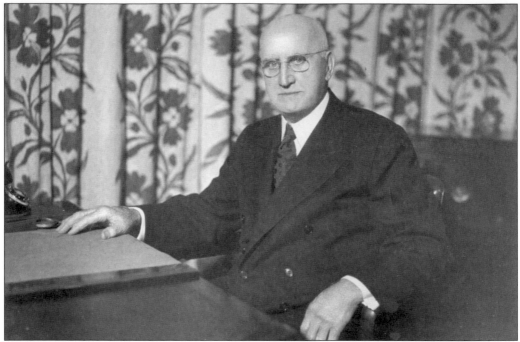

In 1909, Herbert G. Wylie, a native of Ireland and Edward Doheny's operations manager in Mexico, bought 17 Chester Place. Wylie replaced Charles Canfield, Doheny's longtime partner, who left the Mexico operation after the murder of his wife, Chloe. Wylie ran operations, and Frank Seaver was in charge of legal and business activities in Mexico City. (Faculty and Alumni File, Occidental College Library Special Collections.)

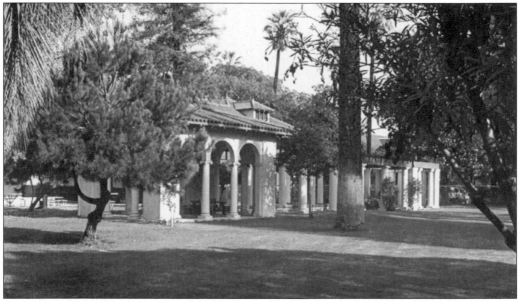

A loggia and broad lawns occupy the space where 19 Chester Place once stood. In 1917, Herbert Wylie purchased the 900-acre Dos Pueblos Ranch on the coastline west of Santa Barbara, where he raised thoroughbred cattle and prize-winning horses. He sold his home at 17 Chester Place to the Dohenys in the 1930s. (Von KleinSmid family.)

Dr. Rufus Von KleinSmid relaxes at 17 Chester Place at a family celebration of his birthday after leaving the presidency of USC in 1947. Von KleinSmid assumed the USC post in 1921 and is credited with building the small, religiously oriented school into an internationally recognized university. He lived on Chester Place from 1930 until his death in 1964. (Von KleinSmid family.)

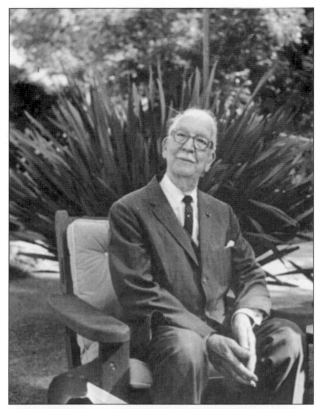

Aided by his wife, Betty, Von KleinSmid threw famous parties and receptions. Sometimes more than 800 faculty, students, and administrators would attend parties at "President Von's" palatial mansion, which he rented from the Dohenys. In 1930, Von KleinSmid moved into 10 Chester Place; in 1940, he headed across the street to the more spacious grounds of No. 17. (Von KleinSmid family.)

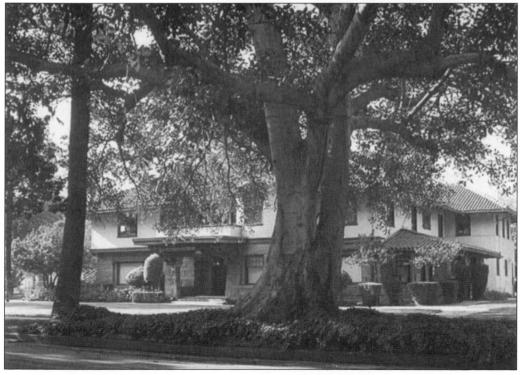

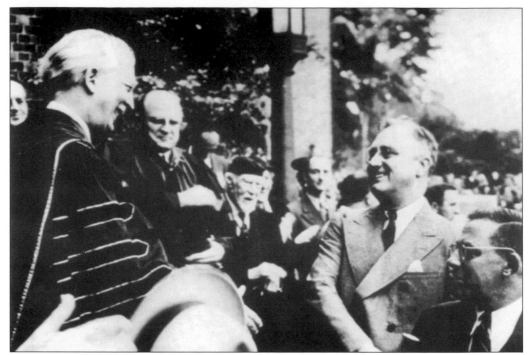

Two presidents greet each other as USC president Rufus Von KleinSmid, left, greets Pres. Franklin Delano Roosevelt, second from right. After 26 years as president, "Dr. Von" served as USC's chancellor from 1947 until his death in 1964. Ironically, during the final years of his life, the USC chancellor lived on the new downtown campus of Mount St. Mary's College. His wife, Betty, died in 1947. (Von KleinSmid family.)

A double-peaked roof marks 15 Chester Place on its north side. B. L. Harding, a real estate investor, sold the 14-room house to Frederick W. Braun for $35,000 in August 1902. Braun, a pharmacist, opened Los Angeles's first wholesale drug business in 1888. He later expanded into manufacturing laboratory equipment. (Security Pacific Collection/Los Angeles Public Library.)

From the south, 15 Chester Place has a long, sloping roof, which gives the house a different appearance than from the north. In 1920, the house had become a rental occupied by Oscar Bennett, a petroleum-industry secretary. By 1930, the house had been demolished to create a more spacious lawn north of No. 17, leaving Herbert Wylie's home without nearby neighbors. (Robinson Collection.)

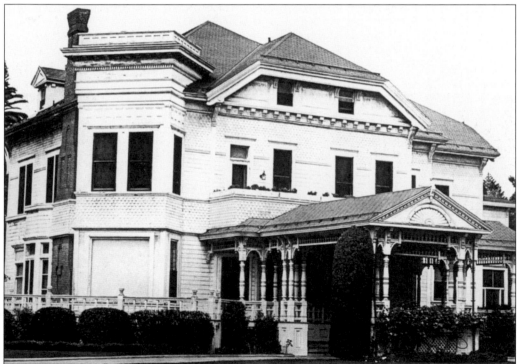

Walter S. Newhall built 21 Chester Place between St. James Park and Judge Charles Silent's land to the east, soon to become Chester Place. The town of Newhall, 35 miles north of Los Angeles, was named for his father, California pioneer Henry M. Newhall. Walter Newhall was president of the California Club for six years before his death on Christmas Day in 1906. (Sisters of St. Joseph of Carondelet.)

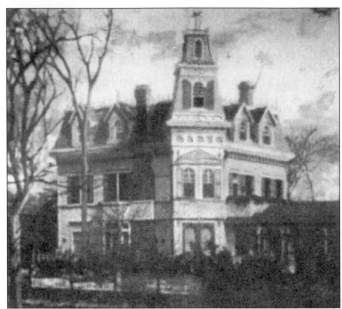

The television series *The Addams Family*, which aired from 1964 to 1966, used 21 Chester Place as a spooky mansion to set the mood at the start of the show. Special-effects technicians added an eerie third floor with a corner tower and altered the lower windows. The show starred John Astin, Carolyn Jones, and Jackie Coogan.

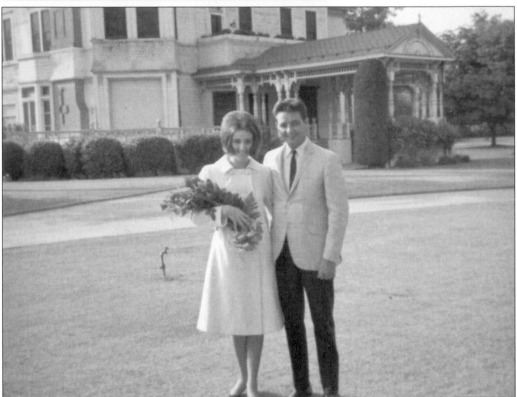

Patrick Greene and his fiancé and future wife, Debbi Morris, stand in front of 21 Chester Place on Morris's 1966 graduation day at the Doheny Campus of Mount St. Mary's College. The Dohenys bought 21 Chester Place before 1915 and rented it out before it was purchased and razed by the Los Angeles Unified School District to build Lanterman High School. (Patrick and Deborah Morris Greene.)

California Residence and Grounds in Winter

In 1900, William Bayly, who had made a fortune in the hardware business in Colorado, built 10 Chester Place. Judge Charles Silent sold the property to Bayly for $10,000 in 1900. Bayly was the brother-in-law of Oliver Posey, who had built 8 Chester Place, the next house to the north. Below the tree branch to the left is the doorway to the gazebo behind the house. (Robinson Collection.)

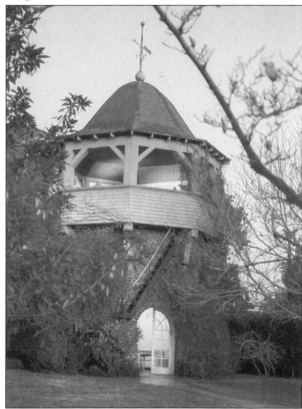

The unusual, two-story gazebo behind No. 10 has a rough-stone first floor and a view of the surrounding foliage and buildings. An outside staircase leads to the second floor. Gazebos have been popular for centuries, but most are simple, one-story structures. As is common to many gazebos, the roof was designed as a cupola. (Sisters of St. Joseph of Carondelet.)

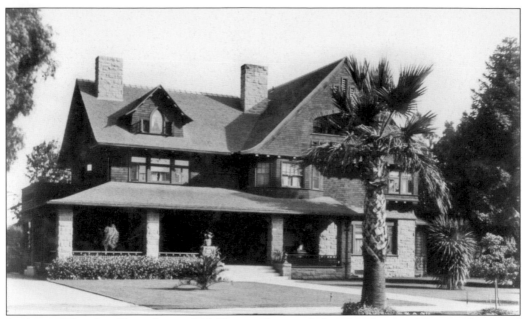

Architect Theodore Eisen designed 10 Chester Place with shingle siding on the upper floors and rough stone on the first floor. After the hardware business, William Bayly turned his attention to mining and owned operations in Colorado, Utah, Nevada, and California. He came to Los Angeles in 1895 and originally lived at 949 West Adams Boulevard. (Security Pacific Collection/ Los Angeles Public Library.)

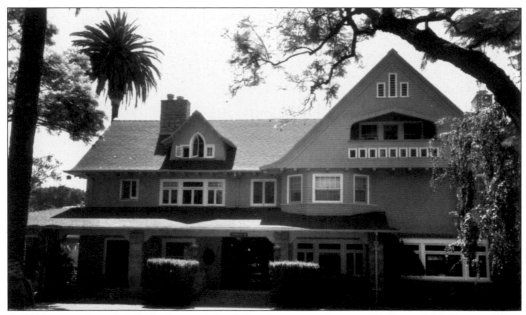

A 1910 extension added a bedroom left of the dormer on the second floor of 10 Chester Place before Edward Doheny purchased the home. The rest of the house was untouched, including the third-floor balcony, beneath an archway. In 1916, the Dohenys' son, Ned, and his wife and daughter moved into the house from his parents' home next door.

Lucy Doheny gave birth to her last four children, all boys, at 10 Chester Place. Ned and Lucy Doheny remained in the house with their family for the next 12 years, sharing the formal garden that lies between 8 and 10 Chester Place with his parents, Edward L. and Estelle Doheny. In November 1928, they moved to Greystone, a 55-room mansion in Beverly Hills. Ned's assistant, Hugh Plunkett, was in charge of building Greystone. (Robinson Collection.)

Narrow windows flank the carved front door of 10 Chester Place. After Ned and Lucy Doheny moved to Greystone, USC president Rufus von KleinSmid rented the house from Ned's parents from 1930 until 1940. It was later used as a convent for the Sisters of St. Joseph of Carondelet, who taught at nearby St. Vincent's Elementary School. (Mount St. Mary's College.)

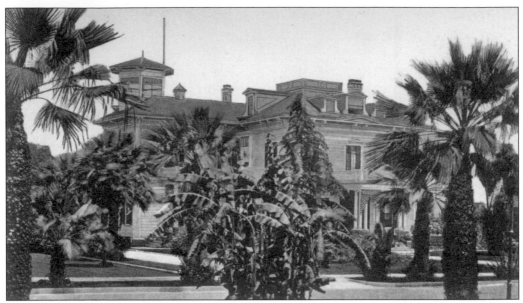

The former Nathan Vail residence, 4 Chester Place, was moved by Judge Charles Silent from its original location facing Adams Boulevard and given the Chester Place address. Silent added a three-story tower behind the house, along with other improvements and additions. When the Silents moved to Glendora, the Dohenys bought the property and demolished the house to expand their lawn. (Robinson Collection.)

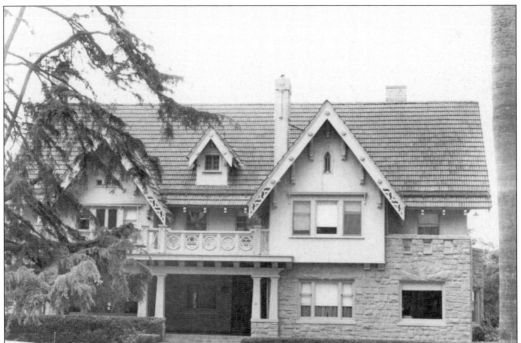

The first owner of 11 Chester Place was widow Artemisia Vermilion, the daughter of a wealthy Ohio hardware merchant. Her mother died when she was 3, her husband when he was 37, and she outlived all four of her children. She adopted her only grandchild, David Gottschalk, and raised him at Chester Place. She died in 1920 at the age of 86. (Sisters of St. Joseph of Carondelet.)

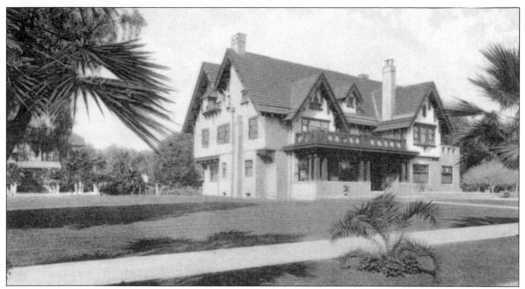

A lawn spreads southward to the left of 11 Chester Place, where Artemisia Vermilion had purchased extra lots. Architects Sumner P. Hunt and A. Wesley Eager designed the Gothic/craftsman-style house with a stone front and a steep, double-gabled roof. By 1941, Edward and Estelle Doheny owned 11 Chester Place and were renting it to Estelle's sister, Daysie Mae Anderson, and her husband, J. Crampton Anderson. (Robinson Collection.)

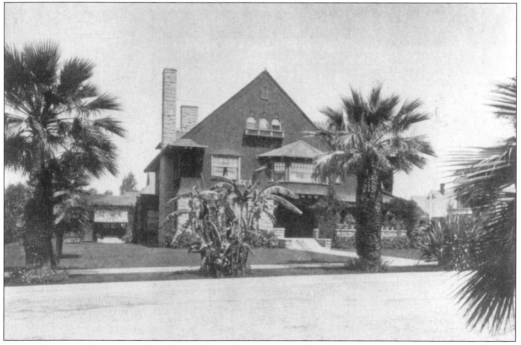

Austrian count Jaro Von Schmidt and his wife, Countess Elizabeth Von Schmidt, owned 1 Chester Place, next to the Twenty-third Street gate. The count, who bought the land from Judge Edward Silent for $4,000, listed himself as a "capitalist" in the 1903 city directory. The house features Tudor and craftsman elements, with exposed rafters punctuating the gabled roofline. (Security Pacific Collection/Los Angeles Public Library.)

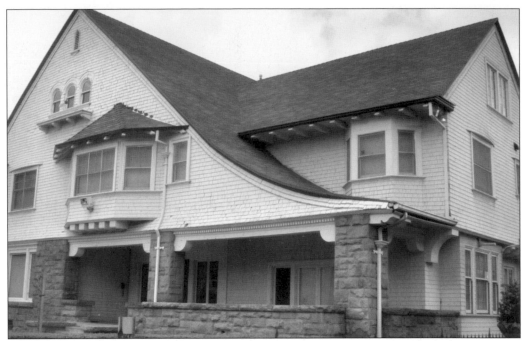

After the Dohenys bought 1 Chester Place, they rented it to department store owner Bernal H. Dyas and his family for $150 a month. In 1930, Betty Von KleinSmid, the only daughter of USC president Rufus Von KleinSmid, married Ernest Potts and rented the house until 1939. (Frank Damon.)

Seen through the fence on Twenty-third Street, an oil derrick soars behind 1 Chester Place. The Dohenys believed oil was under their property but opted not to disturb the pristine setting of their exclusive residential street. In her will, Estelle Doheny left the Chester Place property to the Archdiocese of Los Angeles. The Dohenys greenhouse was dismantled, and the fenced-off area has multiple producing wells. (Frank Damon.)

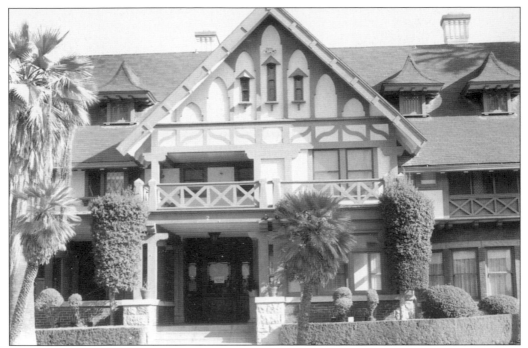

George Wyman, who designed the 1893 Bradbury Building in downtown Los Angeles, and Theodore Eisen were the architects for 2 Chester Place. The Bradbury Building is recognized as a spectacular architectural statement, but this craftsman/Tudor house is more typical of Wyman's later structures. The first owner was William J. Davis, an Arizona surgeon who moved to Los Angeles in 1902. The next owner was cement contractor Carl Leonardt. (Mount St. Mary's College.)

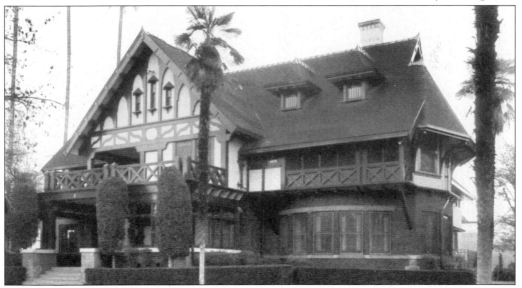

Dr. William Davis became a real estate investor and president of the Western Mutual Bank and Loan Association. By 1930, Charles Wellborn, Edward Doheny's longtime attorney, was renting the home for $150 a month. In 1957, Estelle Doheny approved Mount St. Mary's College to offer summer classes in the building, the beginning of the college's long relationship with Chester Place. (Sisters of St. Joseph of Carondelet.)

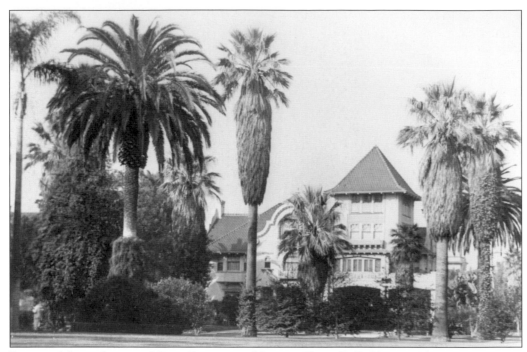

Designed by architects Oliver Dennis and Lyman Farwell, 7 Chester Place is an ornate interpretation of the Mission Revival style. It is a three-story building with a four-story tower. The first owner of the house was Erasmus Wilson, an Ohio Civil War veteran who was president of the St. Louis Fire Brick and Clay Company in Los Angeles. (Security Pacific Collection/Los Angeles Public Library.)

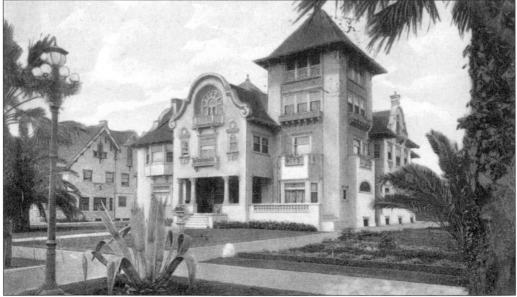

"Chester Place Street Lights—the City's First in a Residential Community," announced the *Los Angeles Times* in its September 27, 1903, edition, describing street lights, such as this one at left, across from 7 Chester Place. Calling the lights "a delicate piece of jewelry," the *Times* described nighttime at Chester Place as "a veritable fairyland." (Robinson Collection.)

An example of the ornate detail of 7 Chester Place is the front door, behind a porch recessed into the first story. After Erasmus Wilson's death on August 21, 1920, the Dohenys purchased the home. From 1926 to 1948, it was rented by Robert Frank Gross, vice president of Mortgage Guarantee Company, and his wife, Buffie. In 1930, they paid $300 a month. (Mount St. Mary's College.)

An arched, stained-glass window with elaborate molding is a focal point of the third floor of 7 Chester Place. Estelle Doheny would walk through Chester Place every day, going north to the Twenty-third Street gate, crossing the street, proceeding south on the west side of the street to West Adams Boulevard, then crossing the street, and returning home. (Mount St. Mary's College.)

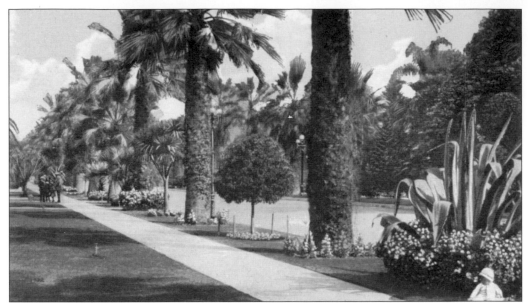

A baby plays in the foreground on the broad sidewalk of Chester Place. Estelle Doheny's ban on picking flowers was so strongly enforced that even after her death, Dr. Rufus von KleinSmid would not pick a flower. Residents and visitors would remark on their fragrance when visiting. The area abounded in rose gardens. (Robinson Collection.)

Judge Enoch Knight built 22 Chester Place. Knight received the building permit to construct his 12-room home for an estimated cost of $7,000 in May 1901. Surgeon Rae E. Smith bought the home after Knight died May 16, 1908, at age 73. The Dohenys later purchased the property. The craftsman-style house has rusticated stone pillars with a porch that extends across the front. (Frank Damon.)

Five

THE CASTLE

In 1948, Estelle Doheny bought the Stimson House at 2421 South Figueroa Street, ridding herself of a USC fraternity as her next-door neighbor to the east and ending her complaints to USC president Rufus von KleinSmid whenever she felt the fraternity members were overly exuberant. Estelle held Dr. von KleinSmid, who rented her mansion at 17 Chester Place, personally responsible for the conduct of the fraternity. After the purchase, she assured herself of quieter neighbors by transferring the deed to the Sisters of St. Joseph of Carondelet for a convent.

From the day it was built in 1891, Thomas Douglas Stimson's three-story, 20,596-square-foot mansion was a Los Angeles landmark. Neighbors called it "the Castle" for its stone, turret-top walls and four-story corner tower. Its $130,000 cost made it the most expensive residence constructed in Los Angeles at that time.

Los Angeles architect H. Carroll Brown was 27 when he designed the mansion in Richardsonian Romanesque style. Stimson, a wealthy businessman, was 63 years old when he moved to Los Angeles from Chicago in 1890 in search of a more healthful climate. He quickly became one of the leading businessmen and citizens of his new city, and he became vice president of the Los Angeles Chamber of Commerce. After his death in 1898, Stimson's wife, Achsah, lived in the house until 1904. After her death, civil engineer Alfred Solano bought the property.

Edward R. Maier, owner of the Maier Brewing Company, bought the house in 1918 from Solano. Maier's company owned the Vernon Tigers minor-league baseball team before selling them in 1919 to Fatty Arbuckle, a superstar in the silent-film era and neighbor around the corner at 649 West Adams Boulevard. In 1940, Maier sold the home to USC's Pi Kappa Alpha fraternity for $20,000.

After Estelle Doheny's death, her Chester Place holdings became the Doheny Campus of Mount St. Mary's College, which was established in 1925 by the Sisters of St. Joseph of Carondelet, who owned the Stimson House. The sisters permitted the house to be used for student housing from 1969 until 1993, when it reverted to convent use.

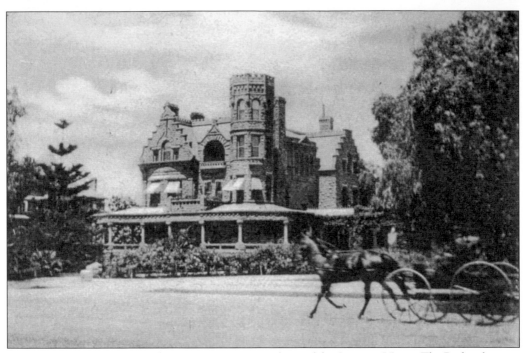

A horse and carriage trot south on Figueroa Street in front of the Stimson House. The Richardsonian Romanesque style, with rough-hewn stone, round-headed arches, and short columns, was popular among architects in the 1880s. The style was never popular in Los Angeles, and today the Stimson House survives as one of Los Angeles's few examples of this period of American architecture. (Connie Rothstein Collection.)

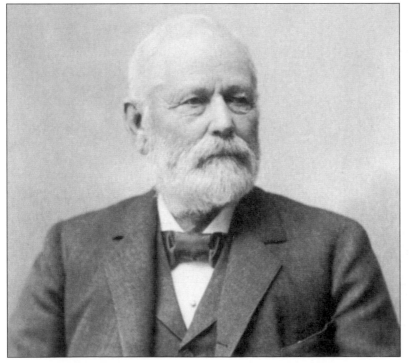

Thomas D. Stimson was a self-made man, leaving home at 14 to start a general merchandise store in Michigan and later developing an extensive lumber empire in the Midwest. As forests diminished in the Midwest, he began buying land in the Pacific Northwest, starting in 1884. His sons moved to Seattle and became leading lumbermen and community leaders. (Sisters of St. Joseph of Carondelet.)

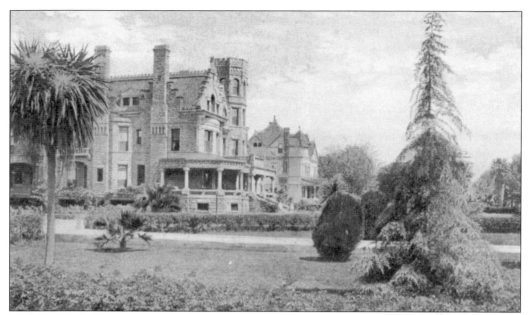

Looking north from a neighbor's lawn, Stimson's house was the most imposing residence on the block. Beyond it is the home of banker Jonathan Slauson. St. Vincent's School now occupies the site of Slauson's home. Architect H. Carroll Brown obtained the large, rough-hewn stone from a quarry near Lordsburg, New Mexico. He used San Fernando sandstone for windows, balconies, and the tower's crown trim. (Marlene Laskey Collection.)

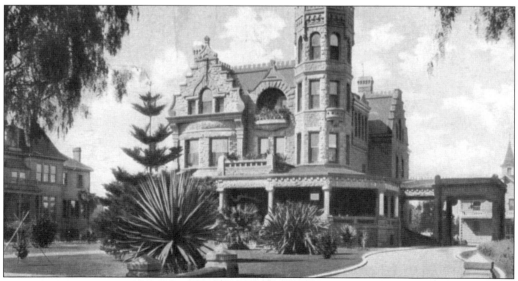

The top of the tower and ridges are crenellated—finished with notched battlements. To the right, a driveway leads through a porte-cochere to a two-story carriage house topped with a spire. At left is the home of former city councilman and real estate investor Frank Sabichi. It has since been demolished. (Connie Rothstein Collection.)

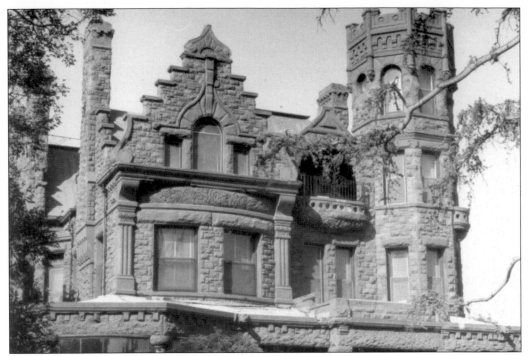

The mansion's front shows a high, stepped, almost Flemish gable containing a Palladian window (left) and a four-story tower (right). Owner Stimson lived in Chicago for five years before moving to Los Angeles and was strongly influenced by that city's architecture. While his sons took over more of the day-to-day operation of his lumber business, Stimson became a major real estate developer. (Sisters of St. Joseph of Carondelet.)

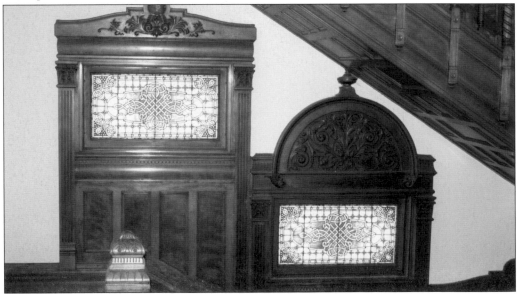

Two stained-glass windows within carved wood moldings allow light onto the stairs. Stimson personally took over and directed the decoration and furnishing of the inside of the house, using the extensive Midwestern contacts from his career as a lumberman to obtain wood, furniture, and glass. (Frank Damon.)

Carved and finely machined wood vie for attention in the ceiling above a stained-glass window in Stimson's house. Stimson made arrangements with the Pullman Company, which was building a set of railcars for the 1893 World's Columbian Exposition in Chicago. Each car used a different kind of wood, and Stimson purchased many varieties to decorate his Los Angeles home. (Frank Damon.)

Thomas Stimson's study, located across the hallway from the two parlors, contains a Diebold Safe hidden behind a wooden door. The rooms of the house contain a variety of woods, including ash, sycamore, birch, mahogany, gumwood, walnut, and oak. An intricate parquet border edges the oak floors throughout the house. The rooms had furnishing to match their walls. (Frank Damon.)

Molded plaster in the front parlor ceiling provides a delicate contrast to the wood carvings. Stimson had pictures taken of the furnishings in his Chicago home and hired the Carsley and East Manufacturing Company to duplicate them and ship the finished products to Los Angeles, where such fine craftsmanship was not readily available. (Frank Damon.)

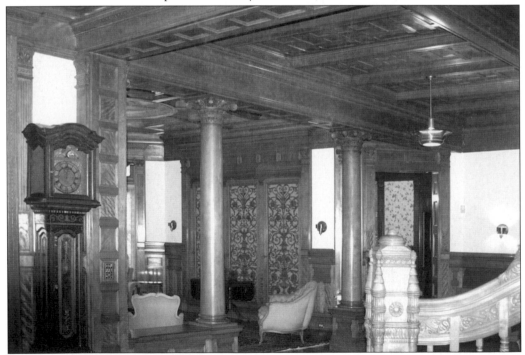

A spacious, wood-paneled entrance greets the visitor entering through the home's front door. To the left is the front parlor, or reception room, followed by the rear parlor with a columned entry, and the dining room with a built-in corner china cabinet. To the right of the entrance is the stairway and Thomas Stimson's study. (Frank Damon.)

Hand-carved newel posts anchor railings in the stairway leading to the upper floors. Beautiful wood is found throughout the mansion, including the back stairs, service areas, and servants' quarters. While the family rooms of mansions often featured such luxuries, their inclusion in servants' quarters was rare. (Frank Damon.)

Four intricate, stained-glass windows above the stairs on the north side of the house are typical of the interior décor. The family's bedrooms were on the second floor, and the children's and servants' rooms were on the third floor. The Stimson House was placed on the National Register of Historic Places on March 30, 1978. (Frank Damon.)

An arched opening separates two chambers in a labyrinth of rooms in the house's full basement. The rooms provide extensive storage and utility areas and include the home's mechanical equipment. The basement can be reached by stairs or an elevator at the rear of the mansion. (Frank Damon.)

An extensive wine cellar with an iron door provided space for wine and other spirits. When a USC fraternity occupied the mansion in the 1940s, the cellar was the scene of various pranks because it was easy to lock someone inside. The fraternity called the house "the Red Castle." (Frank Damon.)

Permanent receptacles are built into the wine cellar's walls to hold various sizes of bottles, including magnums. The temperature in the basement is cool year round. Brewer Edward Maier, who owned the home in the 1920s and 1930s, used the cellar for his extensive collection of wines and liqueurs. (Frank Damon.)

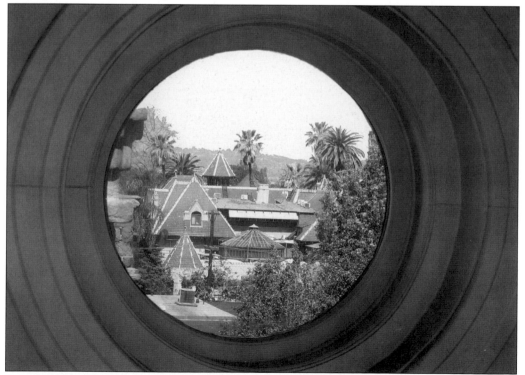

A fourth-floor window in the Stimson House tower looks west toward the multipeaked roof at the rear of the Doheny Mansion at 8 Chester Place. At lower left is the cupola atop the mansion's former Japanese tearoom. To the right of the cupola is the outer glass covering that protects Tiffany's Fabril glass dome in the mansion's Pompeian Room. (Frank Damon.)

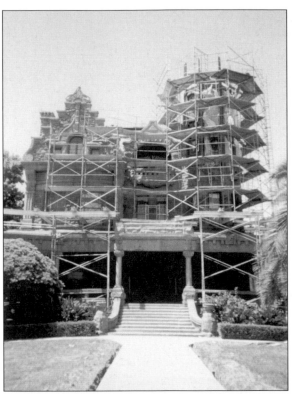

On January 17, 1994, the Stimson House was vacated after the Northridge earthquake caused portions of the exterior to collapse. The most severe damage was to chimneys, parapets, and the tower above the roof level. A seismic study completed shortly before the earthquake allowed rapid repair, and the house was reoccupied in November. (Sisters of St. Joseph of Carondelet.)

Workers in the basement mold material to repair earthquake-damaged portions of the house. The Stimson House was one of the first heavily damaged historic houses restored after the earthquake. The Los Angeles Cultural Affairs Commission named the Sisters of St. Joseph of Carondelet in California its 1996 honorees for historic preservation. (Sisters of St. Joseph of Carondelet.)

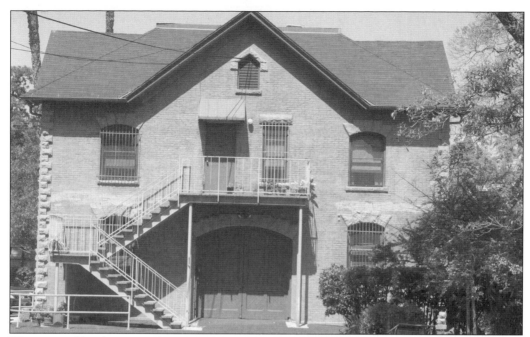

The original brick carriage house, minus its spire, stands at the end of the driveway behind the Stimson House. Horses provided transportation when the Stimson House was built in 1891. The first gasoline-powered car did not appear on a public road until 1893. The second floor has been converted to housing, and an exterior stairway has been added. (Frank Damon.)

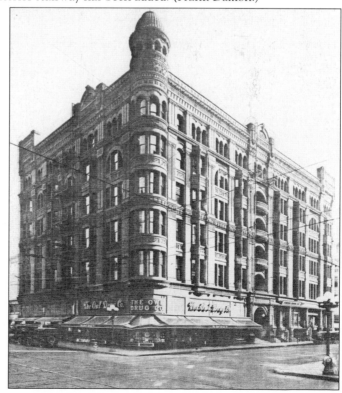

When it was completed in 1893, the six-story Stimson Block, on the northeast corner of Third and Spring Streets in downtown Los Angeles, was the tallest building in the city. It was one story higher than the Bradbury Building, which was erected in 1891 one block to the west. Architect Carroll Brown designed it in the same flamboyant, Richardsonian Romanesque style he had used for the Stimson House. (Sisters of St. Joseph of Carondelet.)

After one year as Los Angeles's tallest building, the Stimson Block was surpassed in height when the seven-story Lankershim Building was constructed directly across Third Street in 1897. Decades later, the need for downtown parking increased. Many buildings were torn down, and by 1963, the Stimson Block was under demolition. (Oreste Fazzi family.)

When the seven-story Lankershim Building rose above the six-story Stimson Building, Thomas Douglas Stimson made plans for the Douglas Building, an eight-story structure on the northwest corner of Spring and Third Streets, to regain the ownership of the tallest building in Los Angeles. He died in 1898 before construction began, and his sons reduced the height to five stories and completed the building in 1900.

Six

NEIGHBORS

As Chester Place flourished, the institutions of the wealthy followed the new residents into the neighborhood, clustering near the corner of West Adams Boulevard and Figueroa Street. Today three massive buildings dominate the intersection—the Automobile Club of Southern California, built in 1923 on the southwest corner; St. John's Episcopal Church, built in 1923 near the northeast corner; and St. Vincent de Paul Church, built in 1925 on the northwest corner.

The Automobile Club, one of the nation's first clubs dedicated to the new motor vehicles, was founded in 1900, with a distinguished group of local residents serving on the board of directors. The club was a pioneer, lobbying to improve roads and traffic laws. It also posted road signs and sent cartographers to create road maps until the state of California took over in the early 1950s.

The Dohenys were important forces and generous contributors in building both churches. In the 1920s, Bishop John Joseph Cantwell began a fund-raising drive to build a new Roman Catholic church on the vacant northwest corner of Adams and Figueroa. Edward Doheny agreed to be its patron and finance construction of a new St. Vincent's Church. The Dohenys' contributions continued through the lifetime of Edward's widow, Estelle. In March 1948, she purchased 2427 South Figueroa, the former home of Los Angeles city councilman Frank Sabichi, for $75,000. At her death in 1958, the property went to the Vincentian order for the church parking lot.

Across the intersection, St. John's Episcopal Church planned replacement of its 1890 wooden building after World War I. Edward Doheny's son, Ned, and his wife, Lucy, were major contributors.

Meanwhile, the stately residences along Adams and Figueroa were adding new neighbors. Some were distinguished families moving to California for the favorable weather, others had found financial fortune in the burgeoning new city, and a few were employed in the newly created motion-picture industry.

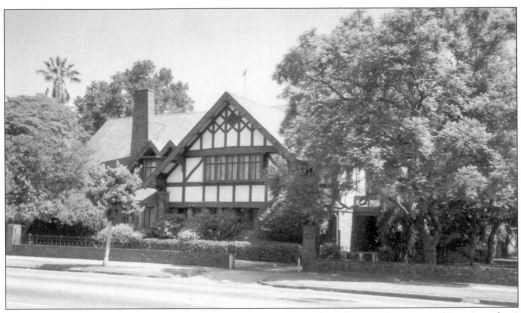

"For two decades Mrs. Randolph Huntington Miner reigned as the social czarina of Los Angeles," declared the *Los Angeles Times*, describing Miner's life at 649 West Adams Boulevard from 1900 until World War I. Julita Miner, granddaughter of a major landholder and former governor of Spanish California, and her husband, Randolph Huntington Miner, bought the newly built home when he retired from the U.S. Navy.

Capt. Randolph Miner was a graduate of Annapolis, and the Miner home included a porthole in a first-floor window. During World War I, the family left the house for Washington, D.C. After the war, they lived in Florence, Italy, until Captain Miner's death at Monte Carlo in 1935. Julita Miner returned to the United States and lived in San Francisco until shortly before her death in Pasadena in 1957.

Nicknamed "the Vamp," Theda Bara was the first sex symbol in the motion-picture industry, making silent movies for Fox between 1914 and 1926. Her popularity declined when censors banned her skimpy costumes. She created what the *Los Angeles Times* called a "sensational flutter" in local society when she rented 649 West Adams Boulevard, which had been a center of social exclusiveness, after the Miners moved to Washington.

Fatty Arbuckle, the first actor in motion pictures to command a salary of $1 million a year, purchased 649 West Adams Boulevard in 1919. After a woman died during a party in San Francisco, Arbuckle was accused of murder. Although acquitted after three trials, his acting career was over. Later the house was occupied by silent-screen star Norma Talmadge, and then by the Dohenys, after the 1933 Long Beach earthquake.

Col. John Stearns's Colonial revival home, built in 1900, is the last surviving mansion on St. James Park, immediately west of Chester Place. Developers George W. King and J. Downey Harvey opened their subdivision in 1888, advertising it as "the most elegant location for private residences in the city." Stearns' architect was John Parkinson, whose later works included Bullocks-Wilshire, city hall, the coliseum, and Union Station. (Robinson Collection.)

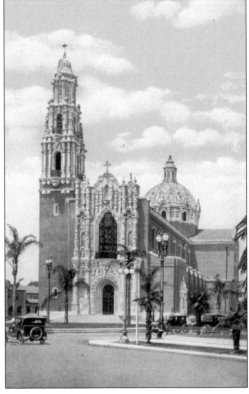

St. Vincent's Church is a spectacular example of Churrigueresque architecture, which is marked by extreme, expressive, and florid decoration. The church is based on Santa Prisca, a historic church in Tasco, Mexico, dating from 1748. St. Vincent's was built at a 45-degree angle to the corner lot so no other buildings could be constructed close by to mar its beauty. (Marlene Laskey Collection.)

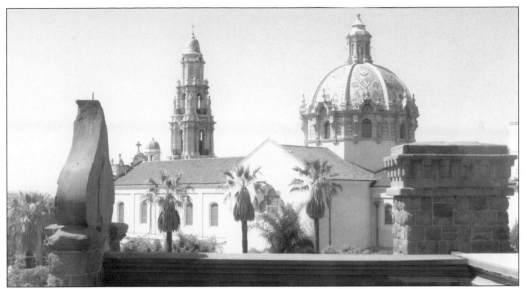

Looking south from the tower of the Stimson House, at 2421 South Figueroa, a portion of the Stimson's House's decorative roofline, left, and the tower and dome of St. Vincent's Church are visible in the background. Groundbreaking for St. Vincent's was in 1923, and the first Mass was celebrated by Bishop John Cantwell on April 5, 1925. (Frank Damon.)

The side entrance on the west wall of St. Vincent's features a statue of Mary. Albert C. Martin, the architect of record, also used the Churrigueresque style in designing Sid Grauman's Million Dollar Theater, at Broadway and Third Street, using statues of showgirls and actors rather than saints. Noted Boston architect Ralph Adams Cram designed St. Vincent's interior and later the Doheny Library at USC. (St. Vincent de Paul Church.)

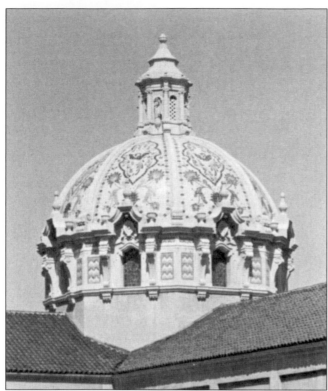

St. Vincent's dome is 45 feet in diameter and varies in thickness from four inches at the top to five inches at the bottom. Because of its innovative design, the city required a load of 45 pounds per square foot to be placed on the dome, and 10 tons hung from underneath to test its strength. There was no measurable deflection under the load. (St. Vincent de Paul Church.)

A broad lawn, framed by a colonnade, serves as a staging area for weddings. St. Vincent's was Los Angeles's third Roman Catholic parish, established in 1887. The first parish was Our Lady Queen of Angels (1822) next to the historic plaza, and the second was St. Vibiana's Cathedral (1876). Before moving to Adams and Figueroa, St. Vincent's Church was at Washington Boulevard and Grand Avenue. (Frank Damon.)

St. Vincent's rectory is at 621 West Adams Boulevard, directly west of the church. A back gate allowed a priest, usually the pastor, to leave the church grounds and cross into Chester Place every morning to celebrate Mass in the Dohenys' private chapel on the third floor of their mansion at 8 Chester Place. (Frank Damon.)

The east side of the rectory features an arched colonnade. In 1865, the Vincentian Fathers started St. Vincent's Academy in the Lugo House next to the historic plaza at Main and Arcadia Streets. In 1911, the Jesuits acquired the college from the Vincentians and renamed it Loyola. Today, as Loyola Marymount University, it is the oldest institution of higher education in Los Angeles. (St. Vincent de Paul Church.)

Eight paintings in St. Vincent's dome depict the four Evangelists and their symbols. Painter John D. Smeraldi also decorated the ceilings of the Los Angeles Biltmore Hotel. The church, with seating capacity for 1,200, is laid out in the form of a Latin cross with a total length of 108 feet. The nave is 67 feet wide. (St. Vincent de Paul Church.)

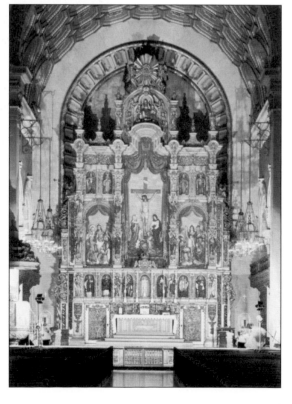

The reredos, the ornamental wall behind the main altar, is gilded and polychrome wood is in the Churrigueresque style. The four Evangelists appear at the top of the four supporting columns, which border three principal panels. Crowning the top is the Holy Trinity. Across the bottom of the altar is a row of 10 saints. (St. Vincent de Paul Church.)

The two statues at the left of the row of saints are St. Peter and St. Edward, the patron saint of Edward Doheny. The face of St. Edward is a likeness of Edward Doheny, and tucked into his left arm is a gift—a small replica of St. Vincent's Church. It was common for those who financed churches to be honored with statues of themselves and family members.

St. John's Episcopal Church parish was organized in 1890, with a wood-shingled church in an orange grove on the south side of Adams Street, just east of Figueroa. In 1922, the original church moved to West Twenty-Seventh Street to allow for the construction of a new church on the site. Contributors included neighbor Sara Posey, the original owner of 8 Chester Place, and Theodore Eisen, one of the 8 Chester Place architects. (Robinson Collection.)

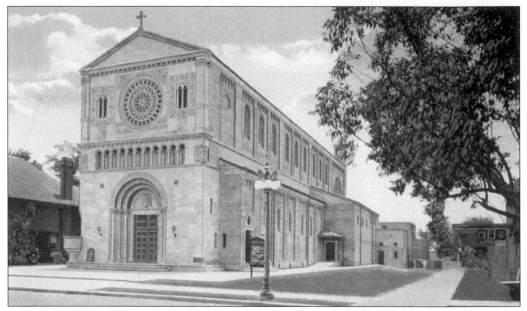

Architect brothers Pierpont and Walter S. Davis designed the Romanesque St. John's Church, which was consecrated in 1925. The West Adams Boulevard facade was carved by 14 Italian artists. The northeast corner features an outdoor pulpit. Ned Doheny and his wife, Lucy, were major contributors to St. John's before moving to Beverly Hills in 1928. (Robinson Collection.)

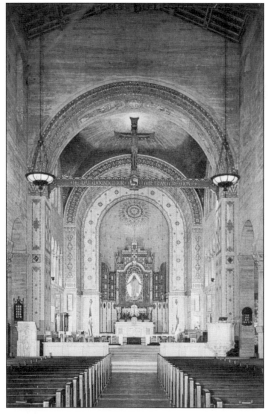

Looking south toward St. John's high altar, a beam supports a cross above the nave. The pulpit is on the right, and beyond the wall to the left is the baptistery, containing the oak altar from the 1890 church. In 1967, a central altar was added in front of the crossing. The remaining black walnut pews seat 700 people. (Seaver Center for Western History Research, Los Angeles County Museum of Natural History.)

The Automobile Club of Southern California (left) faces St. Vincent's Church across Adams Boulevard. The club's headquarters, opened in 1923, was the eighth in the club's history. Sumner P. Hunt, Silas R. Burns, and Ronald E. Coate were the architects for the Spanish Colonial Revival–style building. A Morton Bay fig tree, planted in 1894, still guards the entrance to the parking lot. (Robinson Collection.)

In 1899, the Sisters of St. Joseph of Carondelet started St. Vincent's School at the northwest corner of Washington Boulevard and Grand Street. In 1923, the school (shown in this 1935 photograph) moved to the northwest corner of West Adams Boulevard and Flower Street. These buildings were demolished to make way for the Harbor Freeway, and the school moved in 1954 to 2333 South Figueroa Street. (Sisters of St. Joseph of Carondelet.)

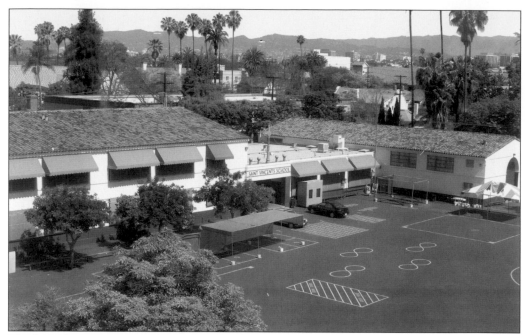

The latest location put St. Vincent's School, above, next to the Thomas Stimson House and the mansions of Chester Place. Estelle Doheny offered 10 Chester Place to the sisters who taught at the school for use as a convent. In 1954, their previous convent at West Adams Boulevard and Flower Street was demolished together with the school for the Harbor Freeway. (Frank Damon.)

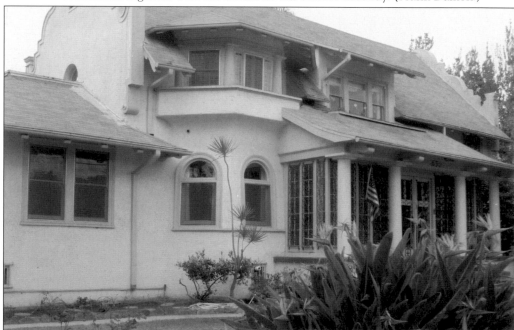

John Posey lived at 650 South Twenty-third Street, just north of Chester Place. He was the eldest son of Oliver and Sarah Posey, the original owners of 8 Chester Place. John bought the house after his parents had left Chester Place. Later he moved to Portland, Oregon, became a successful lumberman, and kept the Twenty-third Street house as a rental. (Frank Damon.)

Seven

MOUNT ST. MARY'S COLLEGE

Located in Los Angeles on two beautiful campuses, Mount St. Mary's College (MSMC) offers associate, baccalaureate, and graduate degrees in the arts, sciences, and selected professions. Founded in 1925 by the Sisters of St. Joseph of Carondelet as a college for women, the school has occupied its Chalon Campus, located in the Santa Monica Mountains above Brentwood, since 1931. Today the Chalon Campus offers the college's traditional baccalaureate program. MSMC is consistently ranked among the top 25 regional colleges in the West in *U.S. News and World Report*'s "America's Best Colleges."

With the consent of Mrs. Estelle Doheny, the college opened an off-campus downtown center in 2 Chester Place in 1957. Following Mrs. Doheny's death, her Chester Place property was left to the Roman Catholic Archdiocese of Los Angeles, which transferred portions of the property to MSMC for its Doheny Campus. In 1962, as many of the longtime residents continued to live out their lives in their palatial homes, Mount St. Mary's College officially opened its second campus. Today the Doheny Campus offers associate and graduate degrees, plus a weekend-college program.

The nine historic mansions that were acquired with the Chester Place property are used today for faculty offices, administrative services, and the campus cafeteria. The houses also contain a convent and student housing. In 1998, a new library, classrooms, and laboratories were constructed according to historic preservation guidelines for adding new structures to a historic site.

The Chalon Campus in the mountains above Brentwood looks down upon the Los Angeles Basin with commanding views, from the mountains behind downtown Los Angeles to the east, past the port of Long Beach, the Palos Verdes Peninsula, and Catalina Island, to Santa Monica on the west. Immediately below is the campus's next-door neighbor, the Getty Center, the internationally famous museum and research institute. (Mount St. Mary's College.)

Looking south in 1959, Bundy Drive advances upward through a tree-shaded canyon toward Chalon Road and Mount St. Mary's College. West Los Angeles is beyond while the city of Santa Monica is above the hill to the right. The quadrangle of the college is 1,017 feet above sea level. (Mount St. Mary's College.)

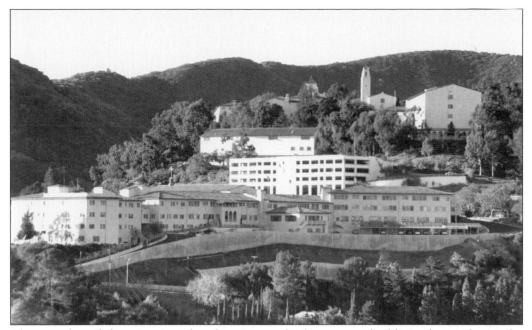

The complex of classrooms, student housing, and other campus buildings that make up the Chalon Campus appear below the ridge of the Santa Monica Mountains. The college's traditional baccalaureate program on the Chalon Campus offers women liberal arts and science degrees. There are about 300 full- and part-time faculty. (Mount St. Mary's College.)

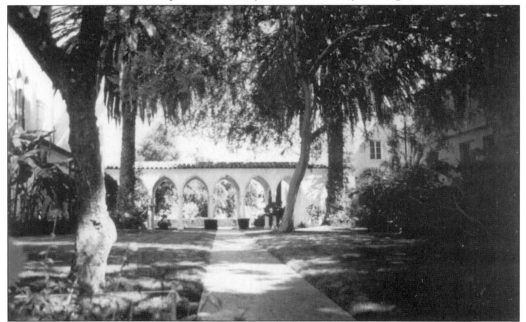

An arcade extends between two buildings in a tree-shaded area of the Chalon Campus. The other side of the arcade offers a view of the nearby canyon. The campus's Spanish Colonial Revival architecture, with its white walls and red-tile roofs, and proximity to Hollywood has made it a favorite of motion-picture location scouts. The campus continues to appear in numerous motion-picture features and television productions. (Mount St. Mary's College.)

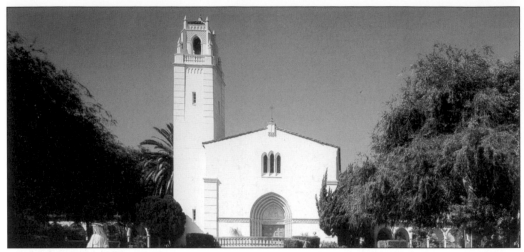

The bell tower and chapel dominate the skyline above the main quadrangle at the Chalon Campus. Behind the chapel and at a higher elevation are additional buildings, tennis courts, and a swimming pool. The student in California's first baccalaureate program in nursing graduated in 1952. Today more than 500 nursing students are enrolled in associate, baccalaureate, or master's programs. (Mount St. Mary's College.)

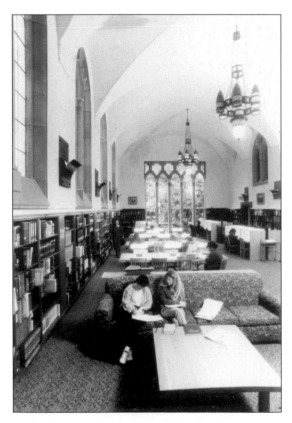

Students study in the four-story Charles Willard Coe Memorial Library with its two-story vaulted ceiling. MSMC has a national reputation in teacher education, receiving more than 26 prestigious Rockefeller Brothers scholarships for students of color, more than any other college in the nation. (Mount St. Mary's College.)

Students stroll past the mansions on Chester Place at the downtown Doheny Campus of Mount St. Mary's College. Residential students are housed on the campus, just one block from public transportation stops leading downtown. Shuttle buses connect the two campuses. (Mount St. Mary's College.)

Docents for public tours of the Doheny Campus gather on the stairs leading to the second floor of the Doheny Mansion at 8 Chester Place. Scheduled public tours started in 2003 and are conducted by a group of volunteers. The public tours by the Doheny docents include the interior of two mansions, the grounds, and the conservatory. (Mount St. Mary's College.)

Students study next to a broad lawn in front of the library on the Doheny Campus. A library, classrooms, and nursing-skills laboratories were built in 1998 in an area that was formerly open space between mansions close to the north end of the campus. (Mount St. Mary's College.)

Students and faculty use the Doheny Campus swimming pool, built in 1906, as part of the conservatory. The swimming pool is constructed with small tiles and is surrounded by the former conservatory's walls with a spectacular view of St. Vincent's Church in the background. The glass top of the pool was removed in 1960 because of deterioration of the steel holding the original 11,000 glass panes. (Frank Damon.)

The Doheny Campus library, built in 1998, reflects the blending of a modern campus with an existing historical area. The library occupies the site that contained the Nathan Vail house after it was moved by Judge Charles Silent during his 1899 subdivision of Chester Place. By 1915, the Vail house had been demolished by the Dohenys to increase the expanse of their north lawn. (Frank Damon.)

Elizabeth Posey Durand, the granddaughter of the original owners of 8 Chester Place, sits before the fireplace in the Great Hall to celebrate her 90th birthday in 2003. To her right is Dr. Jacqueline Powers Doud, president of Mount St. Mary's College. Behind her, from left to right, are Mrs. Durand's daughter Shirley Sundt Hall; her granddaughter Deborah Hall; her son Richard Sundt; and Dr. Doud. (Mount St. Mary's College.)

ACROSS AMERICA, PEOPLE ARE DISCOVERING SOMETHING WONDERFUL. *THEIR HERITAGE.*

Arcadia Publishing is the leading local history publisher in the United States. With more than 3,000 titles in print and hundreds of new titles released every year, Arcadia has extensive specialized experience chronicling the history of communities and celebrating America's hidden stories, bringing to life the people, places, and events from the past. To discover the history of other communities across the nation, please visit:

www.arcadiapublishing.com

Customized search tools allow you to find regional history books about the town where you grew up, the cities where your friends and family live, the town where your parents met, or even that retirement spot you've been dreaming about.